Dan,
Merry Christmas!
Love,
Shanna
"2010"

CHURCHILL
DOWNS

America's
Most Historic Racetrack

KIMBERLY GATTO

Charleston · London

THE
History
PRESS

Published by The History Press
Charleston, SC 29403
www.historypress.net

Front cover: Ryan Armbrust/Sniper Photography. Drawing courtesy of Keeneland Library.
Back cover, top, left to right: Library of Congress, Allison Pareis, Chad B. Harmon,
Keeneland Library, Allison Pareis, Ryan Armbrust/Sniper Photography.
Back cover, bottom: *Courier-Journal*.

First published 2010
Manufactured in the United States

ISBN 978.1.59629.887.3

Library of Congress Cataloging-in-Publication Data
Gatto, Kimberly.
Churchill Downs : America's most historic racetrack / Kimberly A. Gatto.
p. cm.
Includes bibliographical references.
ISBN 978-1-59629-887-3
1. Churchill Downs Racetrack (Louisville, Ky.)--History. 2. Horse racing--Kentucky--
Louisville--History. 3. Churchill Downs Incorporated--History. I. Title.
SF324.35.K4G38 2010
798.4006'876944--dc22
2010002065

In loving memory of

Chutney
(Mid Arc–Appleaday)
1977–2008
One of the great ones

CONTENTS

FOREWORD

Sometimes the place is the thing. Yankee Stadium. Fenway Park. Madison Square Garden. The Forum in Montreal. Lambeau Field. Churchill Downs.

Many fans only see the Twin Spires on the first Saturday in May when it's worth your life to find a parking place and a spot where you can stand and breathe at the same time. They recall Sunday Silence racing in the optimism of Arthur Hancock's Stone Farm going head to head, nose to nose with the cherry and black Phipps colors, representing Arthur's brother, Seth. Under a cunning ride by Pat Valenzuela and a superb training job by Hall of Famer Charlie Whittingham, the strapping black stallion prevailed. Or maybe it's when Winning Colors, the champion filly, defeated the boys in 1988 or, of course, Secretariat.

There are many fine books chronicling the Kentucky Derby, but you need to nearly go back to *Down the Stretch: The Story of Col. Matt Winn*, as told to Frank G. Menke, to uncover an account of America's most famous racetrack that's as enlightening and entertaining as Kim Gatto's.

Lavishly illustrated and doggedly researched, this history of Churchill Downs breathes new life into an old story. You can almost hear the creaking of the old grandstand as it trembles under the impact of extravagant suites along Millionaires Row. Gatto's prose takes us beyond the grandstand and the Derby into the heart and soul of an institution built on the heart of Man o' War and the soul of his son, War Admiral.

Churchill Downs is to horse racing what Fenway Park is to baseball and Madison Square Garden is to basketball. It is the stage where every race is

its own independent drama, not only for the rich and famous but also for the old trainer and owner who never got the big horse.

Just to be able to play on the stage where Gallant Fox and Whirlaway prevailed is enough. Kim Gatto takes us on the memorable stroll from the backside to the paddock with grace and confidence and into the winner's circle. Enjoy the journey.

Michael Blowen
Founder and President
Old Friends Equine
Georgetown, Kentucky

ACKNOWLEDGEMENTS

The author would like to thank the following individuals for helping to make this work possible: Ryan Armbrust/Sniper Photography, Allison Pareis, Jamie Newell, Jessie Holmes, Chad B. Harmon, Jim Evangelou/ Gallery of Champions and Eric Larson/Cardcow for allowing the use of their photographs;

Ann Tatum of Kinetic Corp., Phyllis Rogers and Cathy Schenck of the Keeneland Library, Amy Purcell of the University of Louisville, Diane Bundy of the Kentucky Historical Society, Jason Flahardy of the University of Kentucky and Mark Taflinger of the *Courier-Journal* for assistance with photographs;

Sharon Inglis and Patrick Lennon for their careful reviews of the manuscript;

My wonderful editors at The History Press for their assistance along the way;

My "second family"—Sharon, Scott, David and Nicole Inglis—for their continued support and friendship, and Sharon and Nicole for accompanying me on my first trip to Kentucky; and

All of my family members and friends, and particularly my mom, Ann Urquhart, for always believing in me.

HORSE RACING IN LOUISVILLE

Thoroughbred racing in Louisville, Kentucky, has a rich and storied history. According to local sources, races were held on Market Street in downtown Louisville beginning around 1783. In nearby Lexington, informal races took place in a park-like area called the Commons. Citizens soon began to voice concern with regard to the safety of racing on city streets, which led to the construction of two courses. The first was developed in Lexington in 1789. The other, established in 1805, was based at Shippingport Island, a peninsula near the falls of the Ohio River; it was known as Elm Tree Garden. A third track, the Hope Distillery Course, was created on what are now Sixteenth and Main Streets in Louisville around 1827. There were also a number of smaller private tracks, including Beargrass, which was owned by Captain Peter Funk of the Kentucky Mounted Militia. The majority of races at that time were long-distance contests run in a series of four-mile heats.

The men who organized the first race meet formed the commonwealth's original Jockey Club; it was formally named the Kentucky Jockey Club in 1809. Among its founders was Kentucky statesman Henry Clay. The popularity of thoroughbred racing in the area eventually led to the development of the Kentucky Association in 1826. This group of horsemen was responsible for the creation of various rules and regulations, including the arrangement of standard racing distances, the handicapping of horses based on the amount of weight carried and the adoption of a British rule

whereby a horse's racing age is determined based on his/her age as of May 1 of the current year; this date would later be changed to January 1. The latter served to ensure that horses were not given an unfair advantage by racing against younger, less mature animals in the same age class.

Oakland Race Course was the first Louisville track to gain national recognition. Named for the oak trees that lined its borders, the facility included a three-story Greek Revival mansion with a clubhouse, a hotel and a ladies' pavilion. Oakland was established in 1832 by the Louisville Association for the Improvement of the Breed of Horses, a seventy-six-man organization that included distinguished locals such as Robert Breckinridge, C.W. Thruston and James Guthrie. The course was built on a fifty-five-acre parcel purchased from brothers Henry and Samuel Churchill, with the latter serving as the racetrack's first president.[1]

By the late 1830s, Oakland had become the area's premier thoroughbred track. On Monday, September 30, 1839, it hosted one of the most famous races in Louisville history. It was a face-off between Kentucky's own Grey Eagle and Wagner, the pride of the South. Two other horses also entered the race, which offered a lucrative purse of $14,000 and was composed of three four-mile heats. Grey Eagle, a four-year-old, was the local hero, whom *Harper's* magazine described as "one of the finest-looking horses that ever charmed the eye…sixteen hands high, a beautiful gray, with flowing silver main [sic] and tail."[2] Wagner was a five-year-old chestnut with a blaze and had won twelve of his fourteen starts. Wagner's jockey, an African American slave by the name of Cato, was promised freedom if he were to win the race.

The meeting of Grey Eagle and Wagner brought hordes of racing fans to Louisville. Reports estimated the crowd at nearly ten thousand, which included, among others, U.S. senators Henry Clay and John Crittenden. According to the press of the day, the race drew to Louisville "the Bench, the Bar, the Senate and the Press, the Army and Navy, and all the et cetera that pleasure and curiosity attracted."[3] Common folk who were not granted admission watched the race from trees and other vantage points.

Fresh from a string of recent wins, Wagner captured the first four-mile heat at a time of 7:48. Grey Eagle took an early lead in the second heat and appeared to be gaining ground but was ultimately caught by his opponent. For a while it appeared to be anyone's race, as the horses continually vied for position. In the end, Wagner bested Grey Eagle by a neck to win the second heat and, ultimately, the match. The winning time of 7:44 was declared by the *Louisville Daily Journal* to be "the best time ever, south of the Potomac."[4]

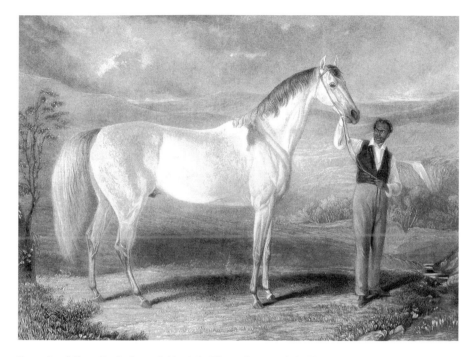

Portrait of Grey Eagle from *Spirit of the Times. Courtesy of the Keeneland Library.*

Grey Eagle's defeat upset the local residents, who felt that their hero deserved another chance. A rematch was thus held on October 5. The local crowd was thrilled when Grey Eagle won the first heat in 7:51. Wagner rebounded, winning the second heat in 7:43, culminating in a showdown for the final, and deciding, heat. Much to the dismay of the Kentuckians, Grey Eagle broke down in the stretch, and Wagner emerged as the victor.

Grey Eagle recovered and began his career as a stud; his offspring would include Robert E. Lee's Traveller. The champion, Wagner, never won another race. He did, however, pass his great speed on to his descendants. Wagner would later become known as the grandsire of Kentucky Derby winners Baden-Baden (1877) and Buchanan (1884).

While the Grey Eagle–Wagner pairing generated a great deal of publicity for Oakland, the track began to fall on hard times in the years to come. It eventually closed in the 1850s after years of financial decline. By the 1870s, the deserted property had become a haven for the dregs of society and, according to sources, the site of frequent petty crimes. With the demise of Oakland, local horsemen set out to establish a new track. In 1858, a

committee met at Louisville's Galt House hotel for the purpose of raising $50,000 to purchase land owned by George E.H. Gray. The result would be the Woodlawn Race Course, a new facility situated on 150 acres near the Louisville and Lexington railroad lines. Woodlawn offered racetracks for both thoroughbreds and trotters, along with a clubhouse, eight stables and separate grandstands for men and women. The clubhouse's tin roof included a hatch with a lookout, a necessity in the event of Indian attacks.

Woodlawn opened on May 21, 1860, to large crowds; despite predictions of severe weather, the stands were filled to capacity. The ladies' areas, in particular, were reportedly jam-packed. It was an exciting day for the sport, with the final race won by the filly Magenta in a time of 1:45 ¾. Later that day, a tornado hit Louisville, causing substantial damage throughout the city. In spite of this, the following week Woodlawn drew a record five thousand spectators; of that amount, six hundred were women.

Woodlawn's spring meet was highly successful, drawing several local sponsors. The Galt House Stakes, funded by the famed hotel, offered a $3,000 purse and an elaborate silver plate to its winner. The inaugural victor of the Galt House Stakes was a filly named Bettie Ward. The track also drew substantial wagering; by the third day of the spring meet, the betting pool had reached $25,000. The *Louisville Daily Courier* later proclaimed that Woodlawn "deserved to be placed among the top ten courses in the world."[5]

In 1860, Robert Aitcheson (R.A.) Alexander of the Woodlawn Association commissioned Tiffany & Company to create a trophy honoring the winner of the track's spring and fall four-mile meets. The elaborate silver challenge trophy, known as the Woodlawn Vase, weighed twenty-nine pounds, measured thirty-four inches in height and cost $1,000 to produce. It was well worth its price to the association, which believed that the trophy would entice owners and breeders to enter its races. The Woodlawn Vase was first presented to Captain T.G. Moore upon the victory of his mare, Mollie Jackson, in 1861; Moore retained possession when his mare, Allegedly, won it the following year. The vase was buried in secrecy when the Civil War reached Louisville, as there was concern that it would be stolen and melted down for its silver. It was exhumed and returned to use around the turn of the century, eventually ending up at Pimlico Race Course in Maryland. To this day, the Woodlawn Vase is presented to the winner of the annual Preakness Stakes, the second jewel in thoroughbred racing's Triple Crown.

The onset of the Civil War obviously interrupted Woodlawn's schedule, although racing continued whenever feasible. After the war, interest in

local horse racing declined, and Woodlawn, like Oakland before it, fell into financial hardship. The course closed in 1870 after the completion of the fall meet, and parcels of land were sold off. There are reports, however, that the trotting track continued to be used until the mid-1870s.

Following the demise of Woodlawn, Louisville horsemen were anxious to bring racing back to the city. By 1872, local thoroughbred breeders had become so discouraged that they were considering relocation to a more profitable area. It was at that time that they joined forces with a group of prominent businessmen, and in 1874, the Louisville Jockey Club and Driving Park Association was formed. Its president was twenty-eight-year-old Meriwether Lewis Clark Jr.

THE EARLY YEARS

THE REIGN OF COLONEL CLARK

Meriwether Lewis Clark Jr. entered the world on January 27, 1846, the fourth of seven children born to Meriwether Lewis Clark and Abigail Prather Churchill. Clark had an impressive family history. His father was a West Point graduate and a Civil War soldier, architect and designer, while his mother was the child of one of Kentucky's most prominent families. Clark's paternal grandfather was General William Clark of the Lewis and Clark Expedition. Abigail Clark died when young Meriwether, or "Lutie," as he was affectionately called, was six years old. Upon her death, the family was divided, and the children were sent to live with various relatives. Lutie was raised by his uncles, John and Henry Churchill, who owned a substantial amount of property in Louisville.

Clark was well educated and attended St. Joseph's College in nearby Bardstown. Upon graduation, he began work as a teller at the Second National Bank in Louisville. Some reports state that within a few years he had moved on to the tobacco business. In 1871, Clark married Mary Martin Anderson, a wealthy heiress from Indiana. Mary's aunt and primary guardian, Pattie Anderson, was the wife of Richard Ten Broeck, the area's most prominent horseman. A noted breeder of thoroughbreds, Ten Broeck was the first to bring American horses to Europe for racing. He was also the owner of the famed racehorse and sire Lexington.

Through his affiliation with the Ten Broecks, Clark developed a passion for horse racing. He and his wife traveled to Europe in 1872, spending a year in England. Together with Richard Ten Broeck and John Churchill,

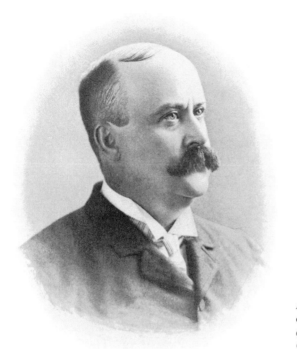

Left: M. Lewis Clark Jr., founder of Churchill Downs. *Courtesy of Churchill Downs Inc./Kinetic Corporation.*

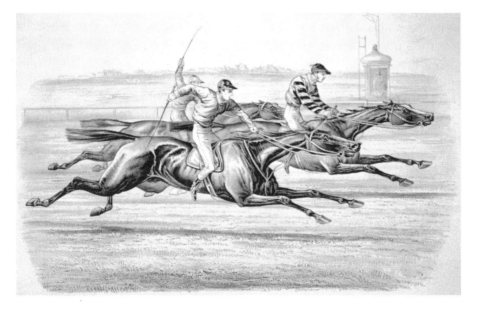

Currier and Ives painting of the Epsom Derby, the race on which the Kentucky Derby was based. *Library of Congress.*

who was visiting from Louisville, Clark watched the English Derby at Epsom Downs. The Epsom Derby, first run in 1780, was Britain's richest horse race. It was run over a dirt track at a distance of 1½ miles (extended in 1784 from its original distance of 1 mile) and was open to three-year-old colts and fillies. While long-distance races remained popular in the United States, the British had abandoned the heat system in favor of shorter-distance races.

While abroad, Clark spoke with several noted horsemen and businessmen with regard to establishing a new track in Louisville. He met with some of the industry's most prominent figures, including Admiral Henry John Rous of England and Vicompte Darn, vice-president of the French Jockey Club. Clark was encouraged to study the successful races in England, which, in addition to the Derby, included the Epsom Oaks and the St. Leger Stakes. The Epsom Oaks for three-year-old fillies was established in 1779 and was named for the home in which the twelfth Earl of Derby first developed the race's concept. Perhaps fittingly, the first Oaks winner, Bridget, was owned by Lord Derby himself. The St. Leger Stakes, open to three-year-old colts and fillies, was in fact the oldest of Britain's classic races, having been founded in 1776 by politician and army officer Anthony St. Leger.

Clark was impressed by the British system and felt that similar races could be met with success in Louisville. He also traveled to Paris, France, where parimutuel betting machines were being used for wagering. This system had been developed by Pierre Oller, a Parisian shop owner, as a replacement for auction pools. Under the parimutuel system, the amount of money paid out to winners was based on the total pool of bets, with a small fee deducted for management. Unlike the auction pool system of betting, the odds in parimutuel wagering were determined only after all bets had been placed.

In 1873, Clark returned home from Europe to put his idea into place. His plan was to hold three major races in Louisville based on the Epsom Derby, the Oaks and the St. Leger Stakes. The U.S. races and their distances would be modeled on the similar contests in England. They would be called the Kentucky Derby (open to three-year-old colts and fillies), the Kentucky Oaks (open to three-year-old fillies) and the Clark Stakes (open to three-year-old colts and fillies). (The Clark Stakes would include older horses after 1901 and would be renamed the Clark Handicap. It would also be run at various distances throughout the years.) Clark also founded other key races, including the Falls City Handicap, a race for fillies and mares aged three years and up, and the Louisville Cup, a handicap race for older horses.

Distance of Clark Handicap

Year(s)	Distance
1875–1880	2 miles
1881–1895	1¼ miles
1896–1901	1⅛ miles
1902–1921	1¹/₁₆ miles
1922–1924	1⅛ miles
1925–1954	1¹/₁₆ miles
1955–present	1⅛ miles

By selling 320 memberships at a cost of $100 apiece, Clark raised $32,000 to establish a facility that would be ideal for hosting such races, as well as carriage rides, fairs and related activities in the off-season. Clark's uncles, John and Henry Churchill, supported their nephew's idea. They leased Clark the land on which the track was to be built, approximately eighty acres situated just a few miles south of downtown Louisville. Located near the Louisville and Nashville Railroad, the site was easily accessible by rail car and was close to various hotels and restaurants that would attract wealthy travelers. With that in mind, the land was cleared and construction began. The facility would be known as the Louisville Jockey Club and Driving Park, as the intent at the time was to include tracks for both thoroughbreds and trotters. (The idea of having a trotting track would be discarded after the inaugural fall meet, citing the "disastrous" results at the Woodlawn course.)[6]

Clark publicly noted the establishment of the new facility in the May 27, 1874 edition of the *Louisville Courier-Journal*. The proposal apparently caused some objections, as another club by the name of the Falls City Racing Association had also expressed interest in establishing a track in the area. Nevertheless, plans moved forward, and articles of incorporation for the Louisville Jockey Club and Driving Park were filed on June 20, 1874.

Architect John Andrewartha, a British immigrant whose work included the Louisville City Hall, was employed to design the early structures. By October 1874, the fencing, main track, porter's lodge, ticket offices and six stables had been constructed by builder Jonathan Jacobs, and the clubhouse was nearing completion. Some reports have stated that Clark underestimated the cost of the project and borrowed money from local merchant W.H. Thomas to complete the clubhouse.

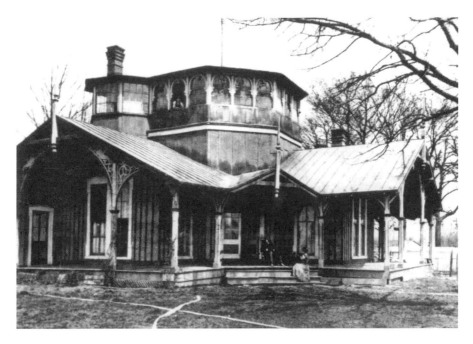

The first clubhouse, built in 1875. *Photo © Churchill Downs Inc./Kinetic Corporation.*

On May 16, 1875, the *Courier-Journal* reported:

> *The track is the broadest in the country, being ninety feet on the home stretch, and eighty on both curves and the back stretch, having quarter stretches and quarter curves. The soil is light and loamy, not too light, but with sufficient clay to give it the springy nature so essential for fast time…The stand is second only to Saratoga and will seat 3,500 persons. The field stand is also superior, and gives excellent opportunities for medium price class.[7]*

The inaugural spring meet was set for six days beginning on Monday, May 17, 1875. The Kentucky Derby, along with three other races, would be held on opening day. The Oaks would take place on the following Wednesday, while the Louisville Cup, a 2¼-mile handicap race, was set for Thursday. (It was common in those days for major races to take place on weekdays, as the typical workweek spanned six days.) Clark and his associates initially believed that the Louisville Cup would be the site's premier event, as it would include more seasoned competitors than would the Derby. The Louisville Cup was ultimately short-lived, however, being discontinued after 1887.

In preparation for the spring meet, Clark set out to introduce parimutuel wagering to the public. On May 1, 1875, the *Daily Louisville Commercial* announced that a representative from the Paris Mutuals [*sic*] Pools Company would be "exhibiting his machines in the rotunda of the Galt House" and instructing patrons on how to place wagers.[8] Sources differ as to whether the machines were actually used in 1875. Some state that both auction pools and parimutuel wagering were available for the inaugural spring meeting; others, including Churchill Downs's later president Matt Winn, noted that the parimutuel machines were not officially used until 1878.

The first Kentucky Derby took place on opening day, May 17, 1875; the weather was sunny and pleasant, and the track was deemed fast. In an effort to attract larger crowds, Clark allowed spectators to enter the infield free of charge. The track, in its earliest incarnation, was far from its perfectly groomed form of today. According to an early interview with Captain J.T. Larkin in the *Louisville Herald Post*, "The day the first Derby was run the race track was in its infancy. The horses had to run over a wooden culvert, and there was a creek in the center of the track."[9]

The media heralded the inaugural Derby, with the *Louisville Commercial* noting that it was "destined to become the great race of this country" and further proposing that "'Derby Day' be observed as a holiday."[10] Approximately ten to twelve thousand spectators were in attendance. The field consisted of fifteen three-year-olds—including two fillies, Gold Mine and Ascension—as well as colts such as Ten Broeck (named for Richard Ten Broeck), McCreery, Volcano and two entries from Henry Price (H.P.) McGrath: Chesapeake and Aristides. Both of McGrath's horses were sired by Leamington, who had been imported from England and was one of the most influential stallions of the era.

McGrath, a colorful character who had made his fortune through gambling, had a plan for the race. The small and speedy Aristides would serve as the "rabbit," setting a fast pace to tire out the front runners and making way for the horse he believed would ultimately win the race, Chesapeake. Aristides, a chestnut, was ridden by African American jockey Oliver Lewis, while the bay Chesapeake was piloted by Robert "Bobby" Swim.

McGrath's plan initially appeared to go as he had hoped. Aristides broke fast and was close to the leaders, Volcano and Verdigris. Chesapeake, the odds-on favorite, was last to break and remained near the back. Aristides took the lead over Volcano shortly after the mile mark. As Verdigris and Volcano challenged in the stretch, jockey Oliver Lewis looked over at McGrath for direction. McGrath, realizing that Chesapeake was unlikely to secure the

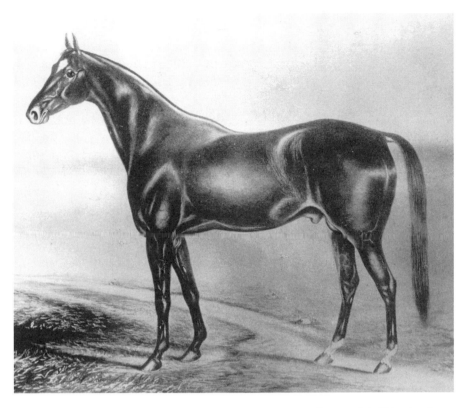

Portrait of Aristides, the first Derby winner, by Harry Lyman. *Courtesy of the University of Kentucky.*

lead, waved him on. Aristides went on to victory in 2:37 ¾, the fastest time for a three-year-old at 1½ miles thus far. Chesapeake, the favorite, finished a disappointing eighth.

Aristides earned a purse of $2,850 for his victory. Named for McGrath's friend Aristides Welch (who was the owner of Leamington), the colt secured himself a place in history as the inaugural Kentucky Derby winner. In deference to that honor, a life-sized bronze statue of Aristides now stands in the courtyard at Churchill Downs. It was created by award-winning sculptor Carl William Regutti and was dedicated in 1987.

Trained by Ansel Williamson, Aristides was noted for having been ridden and trained by African American men. In fact, African American jockeys dominated many of the early races at Churchill Downs, winning the Kentucky Derby fifteen times between 1875 and 1902. One of the greatest jockeys of all time, and a regular rider at Churchill Downs, was Isaac

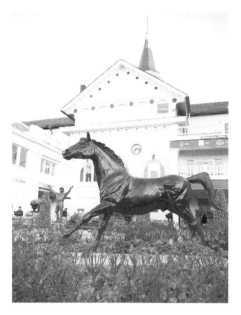

Statue of Aristides in the courtyard at Churchill Downs. *Courtesy of Ryan Armbrust/ Sniper Photography.*

Burns Murphy. His major victories included three Kentucky Derby wins (Buchanan in 1884, Riley in 1890 and Kingman in 1891), four Clark Stakes (1879, 1884, 1885 and 1890) and one Kentucky Oaks victory (1884). Murphy was the first jockey to win the Derby three times and was the only jockey to win the Derby, Oaks and Clark Stakes in the same year (1884).

Born Isaac Burns in Frankfort, Kentucky, Murphy took on his grandfather's surname when he became a jockey at the age of fourteen. According to estimations, he achieved a victory rate of 44 percent during his career, winning 628 of 1,412 starts—a record that has yet to be equaled. He died of pneumonia in 1896 at the age of thirty-six and was buried in an unmarked grave. (Murphy's body would be located and exhumed many decades later and buried alongside the great horse Man o' War.) Nearly sixty years after his death, he would become the first jockey to be inducted into the National Museum of Racing and Hall of Fame. To this day, Murphy holds the record for the most wins by a jockey in the Clark; it would be tied by jockey Pat Day with his fourth Clark title in 2000.

African Americans were regular riders in the spring meet of 1875, which continued in the days following Aristides's victory. The inaugural Kentucky Oaks was held on May 19, 1875, and was won by Vinaigrette, a chestnut filly owned by A.B. Lewis & Co. She completed the 1½-mile race in 2:39 ¾ and received a purse of $1,175 for the win. The Clark Stakes, a 2-mile race at that time, was won by W.G. Harding's Voltigeur in 3:30 ¾.

Much of the facility's early success was due to the efforts of M. Lewis Clark, who was designated a Kentucky colonel for his work in establishing the racetrack. Clark worked tirelessly to promote horse racing as an important event for the well-to-do as well as for the common people. He socialized with wealthy patrons, offering them mint juleps, a specialty southern cocktail made of bourbon, mint and simple syrup. (According to Derby lore, Polish

actress Helena Modjeska was enamored with the mint julep she received from Colonel Clark when she attended the race in 1877, proclaiming the drink "charming."[11]) Clark also continued to encourage the less-than-wealthy to attend the races by offering free admission to the infield on certain days. As a result, people flocked to the races, and records were set. In the 1877 Oaks, the filly Felicia set a speed record for the 1½-mile race, finishing in 2:39. This record would be matched by Belle of Nelson in 1878 and Katie Creel in 1882. In 1879, Lord Murphy overtook Aristides's Derby-winning time when he completed the race in 2:37 flat.

On July 4, 1878, the Louisville Jockey Club and Driving Park became the site of the most famous distance race since the Grey Eagle–Wagner showdown. The horse Ten Broeck, who had placed fifth in the inaugural Derby as a three-year-old, had since set speed records at distances of one, two, three and four miles at the racetrack; he had also won the Louisville Cup and Galt House Stakes in 1876. Foaled in 1872, Ten Broeck was a son of the English horse Phaeton, who had been imported to Kentucky as a three-year-old by Richard Ten Broeck. In a race of multiple heats, the colt was to face the great champion of the West, an undefeated mare by the name of Mollie McCarthy. The stakes were set at $10,000.

The *New York Times* wrote on April 3, 1878, "The owner of Mollie McCarthy thinks she can beat any horse in the country. The mare will be brought from California to Louisville in Budd Doble's car, which has been charted for the round trip, and will probably arrive here about the 1st of May to prepare for the race. Ten Broeck was never in better condition than at present."[12]

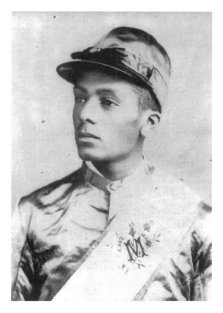

The track was wet on the day of the race—a condition that favored Ten Broeck. Nevertheless, Mollie McCarthy appeared full of vim and vigor, and the pair completed the first mile in 1:49 ¾. The second mile was run in 1:55 ½ with the two horses virtually neck and neck. Mollie took a commanding lead in the third mile, while Ten Brock lagged three lengths

Jockey Isaac Murphy. *Library of Congress.*

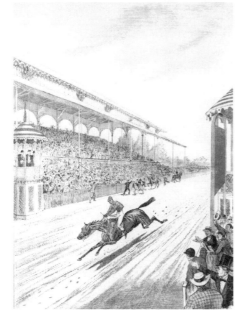

Sketch of Ten Broeck's win over Mollie McCarthy. (Note that the grandstand at that time did not include the famed twin spires.) *Courtesy of the Keeneland Library.*

behind, stunning the local crowd. Soon the mare began to tire, and Ten Broeck made his move, at one point soaring ten lengths ahead while Mollie valiantly struggled to finish. Ten Broeck won easily in 8:19 ¾, slowed by the soggy condition of the track.

While the race was deemed a failure by the press, which had hoped for a faster and more exciting duel, it generated substantial attention for the racetrack. In fact, many felt that the Ten Broeck–Mollie McCarthy match—rather than the Kentucky Derby—first put Churchill Downs on the proverbial racing map. Colonel Matt Winn, later president of Churchill Downs, would describe it as "the last of the great four-mile heat system races in America." The race was so popular that it inspired several folk songs, including what some sources believe to be the first bluegrass music recording, "The Racehorse Song" by Bill Monroe. Another old Kentucky folk song crooned, "When de numbers were hung Old Ten Broeck had won, So deir joy was drunk in juleps and rum."

In the years that followed, Colonel Clark worked tirelessly to draw prominent owners and great thoroughbreds to the racetrack. One such horse, Hindoo, won both the Kentucky Derby and the Clark Stakes in 1881. Heading into the 1881 Derby, Hindoo was sent off as the favorite at 3–1 odds. The colt immediately took the lead but was challenged by virtually every horse in the field. Hindoo took command in the stretch to win the Derby by four lengths. In thirty-five career starts, the colt was never out of the money; his record included thirty wins, three second-place finishes and two third-place finishes. In the year of his Derby victory, Hindoo recorded eighteen straight wins.

Following Hindoo's Derby victory, several renovations were made to the facility, including an expansion of the grandstand, which could now hold up to ten thousand people, and the addition of three towers connected by a

promenade. Flags and flowers gave an appealing aura to the grounds, and a white picket fence replaced an old board fence along the back stretch. The stables could now safely accommodate 310 horses. The betting area remained open to men only, with the ladies' area located at the end nearest to the clubhouse. Steeplechase racing was held on-site beginning on May 18, 1882. The steeplechase course, located in the infield, included various water jumps and stone walls and was designed in a figure-eight pattern. Steeplechasing was popular for several years before being discontinued around 1890, as reportedly M. Lewis Clark felt that the races were "too easy to fix."[13]

On May 15, 1883, the *Courier-Journal* noted:

> *The general appearance of the entire grounds is much added to by the style of picket fencing being put up all around the grounds. The fence is white, with blue posts, and is very attractive. The grand stand has been improved by the continuance of the awning entirely around the south end, over the pooling shed; the ladies' end of the grand stand is being provided with handsome leather cushions. The pooling-shed has been lengthened sixty feet, and is now over two hundred feet long by seventy-feet wide, and is the longest on any race track….Numerous other improvements, such as ticket offices, music stands, flower-beds, etc., are being made, but the place must be seen to be appreciated.*[14]

The year 1883 marked the construction of the "chute," which the *Courier-Journal* described as "a straight extension of the home stretch two furlongs west from the three-quarter pole, thus presenting an unbroken stretch of six furlongs, or three-quarters of a mile directly west from the grand stand." It was developed in the interest of safety so as to avoid starting the horses on a turn. The chute experienced only limited success, however. A February 17, 1890 article in the *Louisville Commercial* stated, "Colonel Clark has come to the conclusion that the chute is a failure. The public does not like it. It is contrary to the principles that made a circular track. The people want to see a race from start to finish."[15] (The current mile chute would be constructed in 1920.)

Sources differ as to the first actual reference to the name "Churchill Downs." Some reports state that the track was first described as such in an 1883 article on the Derby reported in the *Louisville Commercial*. The article stated, "The crowd in the grandstand sent out a volume of voice, and the crowd in the field took it up and carried it from boundary to boundary of Churchill Downs." The track's longtime racing secretary, Charles F. Price,

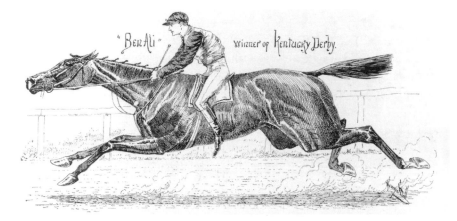

Drawing of 1886 Derby winner Ben Ali from *Spirit of the Times*. *Courtesy of the Keeneland Library.*

credited newspaperman Benjamin Ridgely of the *Louisville Commercial* with that inaugural reference. However, in *Down the Stretch*, Colonel Matt Winn attributed the coining of the phrase to an 1886 *Spirit of the Times* article. Regardless of its origin, the name was commonly used, despite the fact that the facility continued to be formally known as the Louisville Jockey Club.

The spring meet of 1886 would be marred by controversy due to a disgruntled horse owner, James Ben Ali Haggin, an attorney who had earned his wealth through mining during the California Gold Rush and had several horses in residence at the track. Haggin ran a strong breeding operation at his farms in California and Kentucky and owned several top horses, including that year's Derby favorite, Ben Ali. Haggin was a heavy bettor and became enraged when bookmakers were banned from the track at Churchill Downs.

A firm by the name of White & Co. had purchased the wagering rights for that year's Kentucky Derby. When White & Co. required all Derby bookmakers to pay a $100 licensing fee to operate at the track, they refused. As a result, there were no bookmakers on-site to manage the high-dollar bets at the Derby, and Haggin was unable to place large wagers on his horse. Haggin became furious and threatened to remove his entire string of horses from the track stables if the rule were not revoked. To further complicate matters, a track official allegedly responded to Haggin's demands with some choice words.

Ben Ali indeed won the Derby, after which Haggin made good on his word and removed all of his horses from Churchill Downs. In the process, he spread various negative words about the track to those who would listen. As

a result, many eastern horsemen shunned the Derby in the following years. Bookmakers returned in 1887, but entries declined and profits fell, while management issues plagued the track. Additionally, many horse owners and trainers were upset by the length of the races, believing that a 1½-mile stretch was far too grueling for a three-year-old horse. M. Lewis Clark disagreed, noting that the races were modeled after the successful Epsom Derby and Oaks. Finally, after the 1890 running, the length of the Oaks was shortened from 1½ miles to 1¼ miles. At Clark's insistence, however, the Derby remained a 1½-mile race, and entries continued to decline. In 1892, the Derby field consisted of a mere three entries. Six horses entered the 1893 Derby, while five competed in the 1894 event. On May 16, 1894, the *Louisville Commercial* made a plea to Clark:

> *TIME FOR A CHANGE…Owners will no longer enter good colts and trainers will not race them a mile and a half in early May for the money that the Louisville Jockey Club can afford to offer. Reluctantly the warning is given that the cut in the Derby distance must be made to keep the contest above contempt…Racing is no longer a sport. It is a business. The Derby should be made a mile and a quarter.*[16]

Nevertheless, Clark remained steadfast in his ruling. He continued to devote himself to the track, often living on-site in the old clubhouse rather than at home with his wife and their three children. He was also supporting the track financially, using his own funds to cover many of the expenses while the track fell deeper into debt. Sources have stated that during his time as president of the racetrack, Clark never drew a salary. Despite such efforts, however, the track continued to struggle financially. In 1894, it was purchased by a group of investors headed by William F. Schulte, a prominent horse owner and bookmaker, and W.E. Applegate. The track was reincorporated as the New Louisville Jockey Club, with Schulte serving as president. M. Lewis Clark was appointed as a presiding judge.

Under Schulte, Churchill Downs underwent expensive renovations, with some estimates as high as $100,000. Many structures were torn down and rebuilt. The most noteworthy addition was a new 1,500-seat grandstand topped by twin hexagonal spires designed by Joseph Dominic Baldez, a twenty-four-year-old draftsman for the firm of D.X. Murphy & Brother. The spires would add an element of majesty to the track and would eventually become the symbol of Churchill Downs. According to sources, in later years President Matt Winn would tell Baldez, "Joe, when you die there's

Grandstand with twin spires designed by Joseph Baldez, 1901. *Library of Congress.*

one monument that will never be taken down, the Twin Spires."[17] It has been reported that Baldez's original drawings of the grandstand did not include the magnificent spires; Baldez added them to the plans at a later date because he felt that the grandstand needed a unique look.

On February 4, 1895, the *Courier-Journal* reported:

> *The thousands who will pass through the gates at Churchill Downs next will see one of the handsomest and best equipped race tracks in the country. Over $80,000 worth of improvements have been contracted for, and by the time the last nail is driven and the finishing touches are made, the promoters of the New Louisville Jockey Club will probably have expended an even $100,000. Everything has been planned on a magnificent scale, from the $42,000 grand stand down to the twenty or more new stables, each of which will accommodate twenty horses.*
>
> *No better stables are to be seen on any race track in the country than the new ones being put up at Churchill Downs.*[18]

The *Louisville Commercial* also commented on the newly renovated facility, noting, "The new grand stand is simply a thing of beauty, with its two, tall,

tapering spires, its flying colors and its freshly painted surroundings."[19] In addition to its aesthetic qualities, the new grandstand was also practical. Unlike the previous one, the new structure faced away from the afternoon sun, creating a more comfortable area for spectators.

In 1896, at the continued urging of owners and trainers, the length of the Derby was shortened to 1 1/4 miles. The purse was increased as an incentive to boost entries; as a result, Derby nominations rose from 57 to 171. Ben Brush, a bay colt by Bramble out of Roseville, became the first horse to win the Derby at its modern distance. He also was the first Derby winner to be adorned with a garland of roses, which, at that time, were white and pink. (The first red roses would be awarded in 1904.) The garland, originally referred to as a "collar," was the work of Kentucky florist Charles William Reimers. According to Derby lore, the association of roses with the Derby had begun back in 1883, when a New York socialite, E. Berry Wall, presented roses to the ladies in attendance at a post-Derby party. M. Lewis Clark allegedly liked the idea, eventually naming the rose the official flower of Churchill Downs.

Despite such efforts, the track would continue to struggle in the next few years, and Derby entries remained low. Financial and management problems plagued Churchill Downs well past the turn of the century, and it appeared as if the track may be forced to close down. On April 22, 1899, the track was dealt a harsh blow when Colonel M. Lewis Clark died in his room at the Gaston Hotel in Memphis. The cause of death was suicide by gunshot. Clark had been employed as a judge for the spring meet of the Memphis Jockey Club and had been in poor health. At the time of his death, Clark had been suffering from various physical and emotional ailments. The *New York Times* wrote on April 23, "Colonel Clark had been indisposed for several days, and last night his physician announced that he was suffering from melancholia."[20] Some reports state that he had also lost a significant amount of money in the stock market crash and was struggling financially; however, reports differ as to whether this was in fact the case. Clark was buried in Cave Hill Cemetery in Louisville alongside his uncle, John Churchill.

In his lifetime, Clark made many significant contributions to American horse racing. In addition to establishing Churchill Downs and its famed races, he created numerous turf rules that continue to be in use. He also developed the Great American Stallion Stakes, the model for the present-day Breeders' Cup Championships. Additionally, Clark was one of the founders of the American Turf Congress. The *New York Times* noted, "Over 25 years of Colonel Clark's life were devoted to the turf, and no breath of scandal has ever assailed his name."

Chapter 2

A NEW BEGINNING

THE START OF THE MATT WINN ERA

Despite its ongoing financial struggles, Churchill Downs continued operations after the turn of the century. In 1902, the facility served as host of the inaugural Kentucky State Fair. The track was determined as the only area venue that could handle such a large event, with crowds estimated to reach nearly seventy-five thousand over a period of six days. Organized by the Kentucky Livestock Breeders Association, the fair featured a staged collision of two freight locomotives, as well as various horse shows and steam auto races. The fair would be held in Owensboro and then in Lexington over the next two years before returning to Churchill Downs in 1906 and 1907. In 1908, the city of Louisville was named the permanent site of the Kentucky State Fair and constructed its own permanent facility.

Apart from the success of the inaugural Kentucky State Fair, the track continued to sink further into financial ruin. In the fall of 1902, however, Churchill Downs would essentially have a new beginning, thanks to the efforts of a man by the name of Marvin J. "Matt" Winn. A soft-spoken, middle-aged Irish American, Winn had attended the inaugural Kentucky Derby as a teenager along with his father. Since that day, he had developed a strong passion for horse racing, particularly the Kentucky Derby; in fact, Winn had attended every running of the Derby since 1875.

Winn was born on June 30, 1861, in Louisville to grocer Patrick Winn and his wife, Julia Flaherty. He attended Bryant and Stratton Business School and, upon graduation, worked as a bookkeeper before beginning a career in the produce business. In 1887, Winn became a partner in a successful tailoring

company specializing in custom-made suits. He married Mary Doyle in 1888 and would eventually become the father of ten children; three, including his only son, would die in childhood. A heavyset man with clear blue eyes, Winn was well known and highly respected in the Louisville area. He was honored as the first grand knight when the Knights of Columbus Council was established in Kentucky.

In the fall of 1902, Winn was approached by former newspaperman and Churchill Downs's racing secretary, Charlie Price, to inquire whether he would purchase the failing racetrack and essentially save the Kentucky Derby. After giving it substantial thought, Winn agreed. On October 1, 1902, a group of investors led by Winn, Louisville mayor Charles Grainger and Charlie Price

Matt Winn, "Father of the Derby." *Special Collections, Epsom Library, University of Louisville.*

took charge of the track's operations. The articles of incorporation were amended, and Grainger was named as president, Winn as vice-president and Price as secretary. Frank Fehr, president of a local brewing company, and hotel magnate Louis Seelbach also assisted with the rescue efforts. Winn's associates, realizing his marketing savvy, subsequently convinced him to take on the role of general manager at the track.

Churchill Downs began to prosper under Winn's regime. A natural salesman, Winn created a sense of allure and mystique around the track and its races. It was Winn who would later introduce certain traditions to the Derby, including souvenir glasses and the playing of Stephen Foster's "My Old Kentucky Home." He would also use his public relations skills to draw media and celebrities to the Derby, thereby increasing coverage of the event. In Winn's inaugural year as manager, Churchill Downs turned its first profit.

Winn continued Colonel Clark's efforts to make Churchill Downs a place for social events. He raised $20,000 through membership fees and developed a clubhouse for entertaining patrons. Winn also attracted new patrons to the facility through the continuation of a summer concert series originally introduced by Charles Grainger. Notable performers were featured under

the facility's band shell, including John Philip Sousa, Weber's Military Band of Cincinnati, the J.S. Duss Band and Henry Morin's French military band.

The *Courier-Journal* noted in June 1903:

> *Members of the New Louisville Jockey Club have made the park one of the most attractive places in the country for summer amusements. In place of the betting shed is a café. A bandstand has been erected on the grass, and on the beautiful lawn, benches and chairs have been placed...Then there are tanbark walks, growing flowers, Japanese lanterns and other embellishments to make the place attractive by day, gay by night and popular the summer through...Mr. John C. Weber, the director of the band, has dedicated a piece to the New Louisville Jockey Club, and it had the first place on the programme.*[21]

In 1905, Winn founded the American Turf Association, serving as its first president. Two years later, Churchill Downs merged with Douglas Park, another local track, to form the Louisville Racing Association. This new association would oversee the racing schedule and related policies for the area.

Churchill Downs continued to increase in popularity under Winn's command, with various records set from 1904 to 1909. Elwood became the first horse owned by a woman to start—and win—the Derby when he was victorious in 1904. Elwood was the entry of Mrs. Charles Elwood Durnell, who had received the colt from her husband as a wedding gift two years earlier. On June 5, 1907, African American jockey James Lee won the entire six-race card, setting a record that has yet to be surpassed. On May 8, 1909, the *New York Times* reported that "six races were run at Churchill Downs this

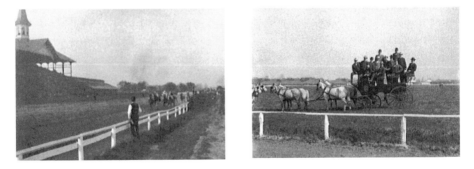

Above, left: A race in 1901. *Library of Congress.*

Above, right: Governor Beckham at the races in 1901. *Library of Congress.*

afternoon, and in each event the track record was broken which establishes a world's record, as a similar performance never before occurred on any race track."[22] The "most notable," according to the *Times*, was that of Belleview, who ran 1 1/4 miles in 2:06 1/5, a twentieth of a second faster than Lieutenant Gibson's 1900 Derby-winning time.

It is important to note that during this time, the Oaks was not held on any specific day. According to the *Encyclopedia of Louisville*, "Between 1906 and 1930 the Derby was something of an Oaks trial. The Oaks did not yet have a traditional day and was usually run two weeks, or more, following the Derby. Fillies who placed in the money in the Derby would often go on to win the Kentucky Oaks. They typically ended their racing careers as broodmares of still more champions."[23] The Oaks also was run at different distances during this period.

Distance of Kentucky Oaks

Year(s)	Distance
1875–1890	1 1/2 miles
1891–1895	1 1/4 miles
1896–1919	1 1/16 miles
1920–1941	1 1/8 miles
1942–1981	1 1/16 miles
1982–present	1 1/8 miles

Matt Winn was faced with a new challenge in 1907, when anti-gambling reformers threatened to end betting at various racetracks. The city administration, headed by a new mayor, opted to ban bookmaking, which at that time was the only form of betting at Churchill Downs. The parimutuel system had been discontinued by Colonel Clark in 1889 under pressure from bookmakers who felt that the system was infringing on their business. By 1907, the original machines imported by Clark had become antiquated and barely operational. Winn, along with Charlie Price and Charles Grainger, identified an exemption in the city's law that excluded parimutuel machines from the ban. Under Winn's guidance, the men located a few machines, developed a patent and created additional machines in Grainger's metal shop. Winn then reintroduced the parimutuel system at Churchill Downs, offering information sessions and distributing instructional brochures to teach patrons how to wager under the new system. The results were successful, with a fivefold increase in wagering on the Derby from 1907 to 1908. A few

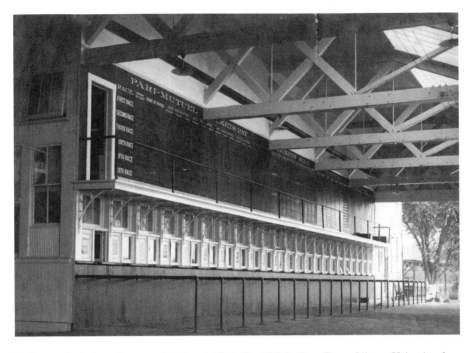

Parimutuel windows, between 1915 and 1920. *Special Collections, Epsom Library, University of Louisville.*

years later, Winn reduced the wager ticket price from five to two dollars, thereby encouraging more patrons to take part. By 1918, the parimutuel system had become the accepted method of betting on thoroughbred racing in North America.

In addition to racing, Churchill Downs continued to prove a useful venue for other important events. In 1910, the first recorded airplane flight in Kentucky took place in the infield at Churchill Downs. Aviator Glenn Curtiss, the founder of Curtiss-Wright Aviation, shipped an airplane to Churchill Downs via rail car, assembled the plane at the racetrack and took off from the infield at a reported speed of sixty miles per hour. The *New York Times* wrote on June 18, 1910, "Glenn H. Curtiss broke the world's record for a quick start today when he rose in his Hudson Flyer at the Churchill Downs Race Track in 4 1/5 seconds."[24] The article further stated that Curtiss "made several flights and circled the track five or six times."

Meanwhile, Matt Winn continued his work at attracting new horses and owners to the track. In 1911, he introduced the Kentucky Endurance Stakes, a four-mile race offering a rich purse. It was based on the longer

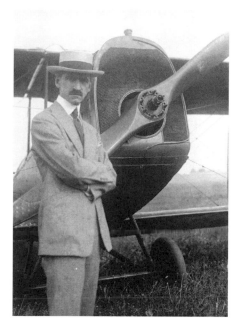

Aviator Glenn Curtiss. *Library of Congress.*

races of years past, made famous by horses such as Grey Eagle and Ten Broeck. The inaugural winner of the Kentucky Endurance Stakes was Messenger Boy, a three-year-old owned by Eugene Lutz. Messenger Boy's victory on October 7, 1911, was particularly significant, as the horse had been purchased by Lutz as a yearling for the astonishing price of $135. The 1912 and 1913 Endurance Stakes were dominated by females, with the mare Sotemia setting a world record of 7:10 4/5 with her win in 1912 and the filly Pandorina taking the crown in 1913. The Kentucky Endurance Stakes would ultimately be short-lived, as it was discontinued after 1913 in favor of the more popular shorter-distance races. The Derby, meanwhile, continued to prosper, with several new records set. In 1913, Donerail became the longest shot to date to win the Derby, paying $184.90 to win at odds of 91–1. The following year, Old Rosebud set a track speed record, completing the Derby in 2:03 2/5 with a win by three lengths. Old Rosebud would return to Churchill Downs to win the Clark Handicap in 1917.

In 1915, Winn generated nationwide publicity for Churchill Downs when he convinced sportsman Harry Payne Whitney to enter his filly, Regret, in the Derby. Whitney, a multimillionaire, was a major figure in thoroughbred racing. He had inherited several great horses, including the stallion Hamburg, from his father, William C. Whitney, and maintained a large breeding farm in nearby Lexington. By 1915, Whitney's stable had three times won the Preakness Stakes (with Royal Tourist in 1908, Buskin in 1913 and Holiday in 1914) and the Belmont Stakes (with Tanya in 1905, Burgomaster in 1906 and Prince Eugene in 1913) but had yet to win the Kentucky Derby. Winn felt that Regret may be the one to change that. A daughter of Broomstick (by 1896 Derby winner Ben Brush) out of the mare Jersey Lightning, the flashy white-faced chestnut was, by all accounts, an outstanding filly. As a two-year-old, she had become the first horse ever

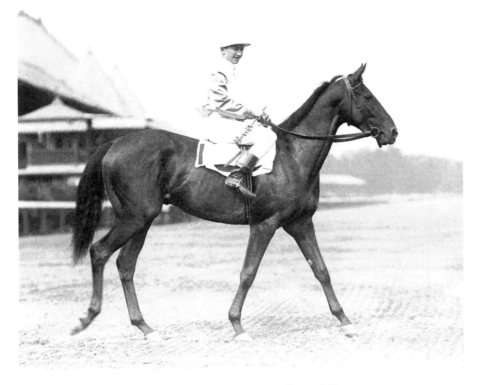

Old Rosebud and jockey John McCabe. *Courtesy of the Keeneland Library.*

to win the Special Stakes, Sanford Stakes and Hopeful Stakes at Saratoga; only three other horses (Campfire in 1916, Dehere in 1993 and City Zip in 2000) would achieve this feat.

In the years since its inception, several fillies had taken on the boys in the Derby, but none had won the race. A few had come close: Lady Navarre had placed second in 1906, while Flamma, Gowell and Bronzewing placed third in 1912, 1913 and 1914, respectively. Winn conveyed his feelings to Whitney that Regret could become the next Derby winner. Whitney was enticed, and Regret was entered as the odds-on favorite in the 1915 Derby. The filly dominated the field of seventeen, easily winning over second-place finisher Pebbles. Publicity surrounding the first filly to win the Derby was instrumental in bringing prestige back to Churchill Downs. Winn would later refer to Regret's victory as "a turning point" in the history of the Kentucky Derby, stating, "It needed only a victory by Regret to create for us some coast-to-coast publicity, and Regret did not fail us." He added, "The Derby thus was 'made' as an American institution."[25]

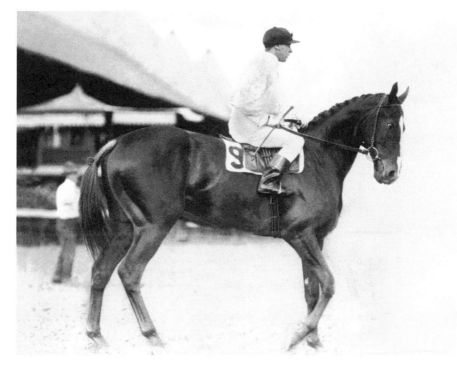

Regret, the first filly to win the Derby, and jockey Joe Notter. *Courtesy of the Keeneland Library.*

Following Regret's Derby win, traditions continued to be created at Churchill Downs, and new champions were crowned. In 1916, a garland of flowers was first presented to a winner of the Kentucky Oaks. The filly Kathleen, the 1916 Oaks champion, was adorned with a garland of roses similar to those awarded to the annual Derby winner. In later years, the Oaks garland would be made of lilies, thereby coining the term "Lillies for the Fillies." In 1917, the English colt Omar Khayyam became the first foreign-bred horse to don the Derby's garland of roses. In attendance for Omar Khayyam's victory was the notorious Mexican revolutionary general Pancho Villa, who reportedly was a fan of horse racing.

In 1918, Johnson N. Camden was named president of Churchill Downs, replacing Charles Grainger. That year also marked the victory of an unlikely Derby winner, Exterminator. A seventeen-hand chestnut gelding, Exterminator was originally purchased as a running partner for his esteemed stable mate, Sun Briar. Despite being a half brother to 1913 Derby winner Donerail, Exterminator appeared gawky and underdeveloped and was,

in fact, often called a "truck horse" or "goat" by his owner, Willis Sharpe Kilmer. The horse's sole purpose, according to Kilmer, was to be a workout partner for Sun Briar. However, Kilmer's trainer, future Hall of Famer Henry McDaniel, was impressed by the lanky chestnut and urged Kilmer to enter the horse in the Derby after Sun Briar came up lame. Kilmer initially balked at the suggestion, noting that he was embarrassed to have "such a horse" donning his stable colors. Reportedly, even jockey Willie Knapp was disappointed at the prospect of riding Exterminator in the Derby. Matt Winn, however, had seen Exterminator's workouts and convinced Kilmer to give the horse a chance.

Sent off at odds of 30–1, Exterminator dominated the field of eight over a deeply muddy track to win the 1918 Derby. He would continue on to a very successful racing career. Among other victories, Exterminator would win the Clark Handicap at Churchill Downs on May 20, 1922, carrying a weight of 133 pounds—13 pounds more than any of his competitors.

Churchill Downs was sold to a Louisville syndicate in 1918 for the sum of $650,000. The syndicate, the Kentucky Jockey Club, was interested in

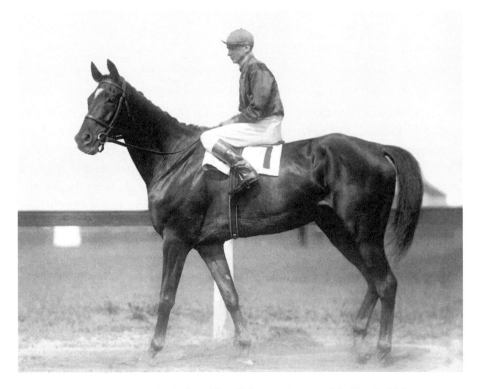

Exterminator, shown here with jockey Albert Johnson. *Courtesy of the Keeneland Library.*

The paddock area between 1915 and 1920. *Special Collections, Epsom Library, University of Louisville.*

gaining control of all the racetracks in the area. The Kentucky Jockey Club immediately set out with further renovations to the property, including an extension of the grandstand by three hundred feet as well as the construction of new boxes and administrative buildings. Additionally, stairways were rebuilt on the inside of the grandstand in order to avoid crowding and distracting the horses as they passed by.

Winn, meanwhile, continued his work in bringing Churchill Downs to the forefront of the media while also assisting with charitable efforts. When a potato shortage occurred during World War I, Winn converted the infield to a potato farm. The land yielded one thousand bushels of potatoes, which were sold off to benefit the wartime efforts of the American Red Cross.

In 1919, Churchill Downs was once again in the news when a chestnut colt by the name of Sir Barton won the Kentucky Derby and then went on to capture the Preakness Stakes in Maryland and the Belmont Stakes in New York. Sir Barton, sired by Star Shoot out of Lady Sterling, was foaled at John Madden's Hamburg Place Farm in Kentucky. After the horse failed to post a win in six races as a two-year-old, Madden sold Sir Barton for $10,000 to John Kenneth Leveson "Jack" Ross, a Canadian businessman. Ross subsequently sent the colt to Harvey "Guy" Bedwell for training. Sir

Barton entered the Derby as a maiden three-year-old to serve as a rabbit for his stable mate, Billy Kelly. Ridden by Johnny Loftus, Sir Barton surprisingly led the field of twelve horses from start to finish, ultimately winning the Derby by five lengths. He went on to capture both the Preakness Stakes at Pimlico Race Course and the Belmont Stakes at Belmont Park. This trio of wins would later be referred to as the "Triple Crown," although no such phrase was used at that time. The term would not be formally attributed to the three races until 1930, when Gallant Fox would emerge as the victor.

As the new decade began, renovations continued to be made at Churchill Downs. The *Louisville Herald* reported on May 8, 1920:

> *Since the last meeting, the club has spent a fortune in constructing a large addition to the grandstand, which will afford a seating capacity equal to that of any race track in the country. Other improvements including the sloping and paving of the grandstand lawn, the construction of additional entrances, enlarged pari-mutuel quarters, and additional parking space for automobiles.* [26]

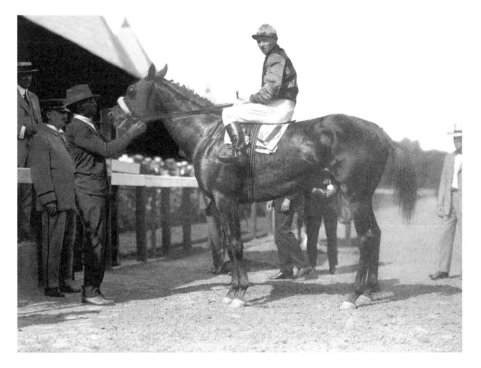

Sir Barton (shown here with jockey Earl Sande), the first winner of the Triple Crown. *Courtesy of the Keeneland Library.*

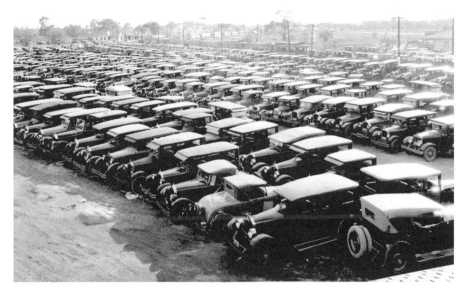

Above: Cars in the parking lot, 1927. *Special Collections, Epsom Library, University of Louisville.*

Below: Grandstand with columns. Note the plaques featuring the names of past Derby winners. *Courtesy of the Kentucky Historical Society.*

Another notable enhancement was the creation of plaques around the top of the grandstand building, with each plaque listing the name and year of a Derby winner. The *Courier-Journal* reported on April 6, 1920, "From a standpoint of beauty, Churchill Downs will surpass any other racetrack of the present day when completed. The huge columns supporting the grandstand will be artistically decorated and on the name of each will be engraved the name of the previous Derby winners, and the year in which they won the classic."[27]

The Kentucky Derby was now regarded as one of America's greatest sporting events.

Chapter 3

THE ROARING TWENTIES

With the onset of Prohibition in 1920, alcohol was no longer offered for sale at the races. Many Kentucky distilleries were forced to shut down, with some closing their doors indefinitely. In addition to the lack of alcohol, the 1920 Derby was noted for the absence of one strong figure—a colt by the name of Man o' War. Owned by Samuel Doyle Riddle, Man o' War was regarded as the greatest racehorse that ever lived—a title that, many believe, still stands today. He was bred by August Belmont Jr., founder of the famed Belmont Park racetrack in New York, and was sired by Fair Play out of the mare Mahubah. Man o' War was named by Mrs. Belmont in honor of her husband, who was serving in the army when the horse was foaled. By age three, Man o' War stood at 16.2 hands and weighed 1,150 pounds, with a seventy-two-inch girth. His chestnut coloring and strong stature earned him the nickname "Big Red."

Man o' War had won nine of ten starts as a two-year-old; many believed that his one loss could be attributed to starter problems and errors by his jockey. Despite this stellar record (and the prestige of the Derby), owner Sam Riddle opted not to bring the colt to Churchill Downs. Riddle felt that the 1¼-mile distance was too long for a three-year-old so early in the season, and he did not want to risk his colt becoming ill or breaking down. With no established Triple Crown series as of yet, Riddle set his sights on the Preakness and the Belmont, which Man o' War won handily. In his absence, Paul Jones, who had twice been defeated by "Big Red," would win the 1920 Derby. (As an aside, the second-place Derby finisher, Upset, was the only

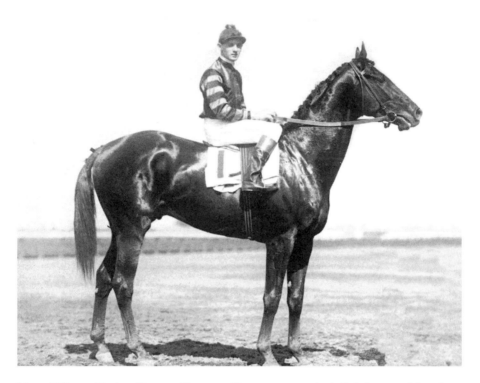

Man o' War and jockey Clarence Kummer. Contrary to popular belief, the great Man o' War never raced at Churchill Downs. *Courtesy of the Keeneland Library.*

horse to defeat Man o' War. The one loss, mentioned above, occurred in the 1919 Sanford Memorial Stakes.)

In spite of Prohibition, Churchill Downs flourished in the years following Paul Jones's Derby win, as the Kentucky Jockey Club was able to bring the track to prominence. The Jockey Club also acquired four additional tracks during this time: Lexington, Latonia and Douglas Park in Kentucky; and Washington Park in Illinois. The year 1923 marked the first time that the Derby was started on a straightaway. At Winn's insistence, according to the *Courier-Journal*, there was "a removal of the finishing line, which automatically placed the quarter post in the home stretch, off the bend."[28] This amendment was necessary because of the probable large field. The race that year, which was won by Zev, included twenty-one entries, more than double the number entered in the prior year's Derby.

One of the most memorable fillies to race at Churchill Downs during this time was Princess Doreen, who won the 1924 Kentucky Oaks (after the

disqualification of Glide) and the Falls City Handicap. "The Princess," as she was known, won races against colts and carried weights of up to 133 pounds. When she retired at age six, she was America's leading female money winner, a record formerly held by the legendary Miss Woodford. Princess Doreen was bred by John E. Madden, breeder of Derby winners Old Rosebud, Sir Barton, Paul Jones, Zev and Flying Ebony. Princess Doreen's dam, Lady Doreen, was a half sister to Sir Barton.

The year 1924 generated a wave of publicity for Churchill Downs with the running of the Golden Jubilee Derby. In honor of this anniversary, the Derby purse was increased to $52,775, and a $5,000 gold winner's cup was created. According to some sources, it was also the first time that "My Old Kentucky Home" was played as the horses were led to the post parade. (Other sources are less specific, stating that the song was first played at the Derby sometime between 1921 and 1930.) In preparation for the Jubilee Derby, several renovations were made to the facility, which included an extension of the clubhouse by four hundred feet in anticipation of large crowds.

Black Gold, the 1924 Derby winner, was owned by Rosa Hoots, an Oklahoma-based Native American. Her late husband, Al, had owned a cherished race mare named Useeit. According to Derby lore, Al Hoots entered Useeit in a claiming race in Mexico but made it known that nobody should claim her. Some stories claim that a man named Ramsey claimed the mare and Hoots allegedly threatened him with a shotgun. Other tales state that Hoots simply took off with the mare and crossed into Mexico. In any case, Al Hoots was banned from subsequent racing. The following year, on his deathbed, Hoots told his wife that he'd had a dream in which Useeit was bred to a leading sire and bore a future Kentucky Derby winner. After his death, Rosa honored her husband's wish and bred the mare to E.R. Bradley's famed sire, Black Toney. The breeding was financed by the discovery of oil on the Hootses' property; thus, the resulting colt was named Black Gold.

As a two-year-old, Black Gold won nine of his eighteen starts, including the Bashford Manor Stakes at Churchill Downs. The following year, he won seven races in a row, culminating in a crushing win in the Louisiana Derby. Reportedly, Rosa Hoots was offered the sum of $50,000 for the horse at this time but refused to sell him. Black Gold also won the inaugural Derby Trial at Churchill Downs, which was designed to serve as a Derby prep race. (Originally called the Derby Trial Purse, the race was held sporadically throughout the 1920s and 1930s. It was renamed the Derby Trial Stakes in 1938 and was held on the Tuesday prior to Derby Day. In 1982, the race

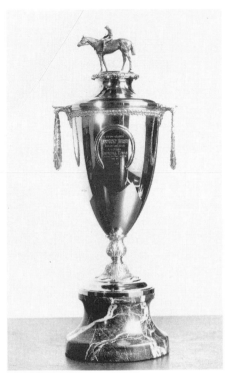

Left: The Derby trophy. *Special Collections, Epsom Library, University of Louisville.*

Below: Start of a race, 1927. *Courtesy of the Kentucky Historical Society.*

was moved to the Saturday prior to the Derby. The trial race is still held but no longer serves as a legitimate Derby prep race due to the current trend toward giving Derby contenders more time in between starts.)

Following his victory in the Derby Trial, Black Gold recovered from various bumps and checks to soar past Chilhowee for the Derby victory. (Chilhowee, a champion in his own right, would go on to win the Clark Handicap at Churchill Downs later that year.) Black Gold was presented with the Golden Jubilee Trophy, the forerunner of the current Derby trophy. According to sources, the idea of a trophy had been considered in prior years. When Morvich won the Derby in 1922, his owner was presented with a six-piece gold buffet service that included a loving cup and two candlesticks. The 1923 winner, Zev, had received an earlier version of the Jubilee trophy.

Churchill Downs continued to prosper under the Kentucky Jockey Club, which added to its string of racetrack properties. In 1925, it acquired the newly constructed Fairmount Park in East St. Louis, Illinois, and in 1926, it established Lincoln Fields in Crete, Illinois. The Kentucky Jockey Club dissolved in late 1927 and reorganized as a separate holding corporation (the American Turf Association) under the laws of the State of Delaware; the process was finalized in January 1928. At that time, the American Turf Association became the holding company for seven tracks: Churchill Downs, Lexington, Douglas Park and Latonia in Kentucky; and Lincoln Fields, Washington Park and Fairmount Park in Illinois. In March 1928, the track experienced a change of leadership when Samuel Culbertson was named president of Churchill Downs. A Louisville native, Culbertson had been associated with the group that purchased Churchill Downs in 1902 and, since that time, had served on the board of directors.

Chapter 4

THE 1930S

THE DEPRESSION YEARS

The onset of the Depression hit Kentucky residents hard. From 1928 to 1933, the annual per capita income level for Kentucky residents fell from $371 to $198. This resulted in a substantial decline in wagering at Churchill Downs. According to a 1932 article in the *Courier-Journal*, "Only a few, if any bets were placed without earnest deliberation, forethought and study. Every so often, one from the line would step quietly to the window, purchase a ticket, and walk away with determined strides. As if to say, 'Well, I've done it. If I lose I'm sunk.'"[29]

The Depression took its toll on horse owners as well, with Derby nominations declining from 150 in 1930 to 13 in 1931. The winner's purse, reflecting the times, was reduced from $50,000 to $37,000. Despite these changes and a decline in wagering, Churchill Downs remained a popular venue, a small means of escape from the darkness of the Depression. At the start of the Depression era, horse racing ranked second only to baseball as America's most popular spectator sport.

In 1930, Churchill Downs introduced a "stall machine," a precursor to the starting gate. In the early years, races had been started by a drum tap along with the dropping of a flag. Horses were called from the paddock to the track area by a bell. A string was stretched across the track, calling the horses into position. In later starts, a web barrier was used. None of these starting methods was without problems, as horses often had false starts and jockeys had trouble controlling their mounts.

Above: Patrons enjoying the garden area, circa 1927. *Courtesy of the Kentucky Historical Society.*

Below: Jockeys awaiting a race call, circa 1930. *Courtesy of the Kentucky Historical Society.*

The 1930 Derby was won by Gallant Fox, who went on to sweep the Preakness and Belmont and thus become the second Triple Crown winner in history. Charles Hatton, a columnist for the *Daily Racing Form*, was attributed as the originator of the term "Triple Crown" following Gallant Fox's victory. However, other sources cite the *New York Times* as originating the term. The *Times* had reported in 1923, "Thomas J. Healey had Walter J. Salmon's Preakness winner, Vigil, and his owner wired today that he would be here Friday to see his colt try to capture his second classic in the triple crown of the American turf."[30] (In that year, the Preakness Stakes was held before the Derby.) Gallant Fox's capture of the Triple Crown in 1930 came eleven long years after Sir Barton's dominance of the three races.

The perceived glamour of Churchill Downs and the Derby drew the rich and famous to the twin spires during this time. In attendance for Gallant Fox's Derby win at Churchill Downs was Edward George Villiers Stanley, the seventeenth Earl of Derby. Other notables who made their way to Churchill

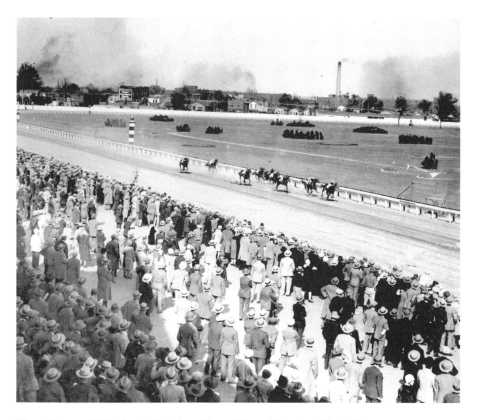

The fall meet, 1930. *Special Collections, Epsom Library, University of Louisville.*

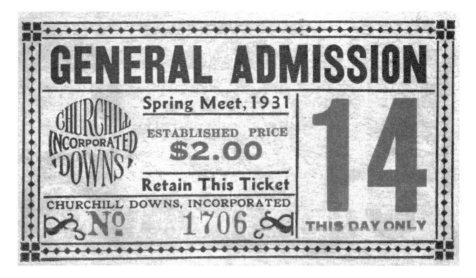

1931 ticket stub. *Author's collection.*

Downs in the 1930s included baseball star Babe Ruth, boxers Jack Dempsey and Gene Tunney, singer Al Jolson and FBI director J. Edgar Hoover.

In 1931, the Derby was broadcast via radio to England for the first time. This marked the earliest international radio broadcast of the race. It was won by Twenty Grand, whose time of 2:01 4/5 broke the track record earlier set by Old Rosebud. That same year, the Triple Crown races were held in their current order, with the Kentucky Derby first, the Preakness Stakes second and the Belmont Stakes third. In earlier years, the Preakness Stakes had been held prior to the Kentucky Derby eleven times. In 1917 and 1922, the Kentucky Derby and Preakness Stakes had occurred on the same day, rendering a Triple Crown virtually impossible.

At Burgoo King's Derby victory in 1932, the roses presented to the winning horse took on a more elaborate form. The collar of old was replaced with a garland of 554 red roses sewn on to a green satin backing. The following year, Prohibition was lifted, and Churchill Downs resumed selling beer after a fifteen-year ban. Whiskey returned in 1934 at a cost of ten to twenty-five cents per glass. During this time, additional improvements were made to the facility. The winner's presentation area was moved from the track (where the winner would stand inside a circular area that had been outlined in chalk) to a designated location beside the clubhouse. This new area would be used until 1938, when a presentation stand was created in the infield area.

The 1933 Derby was characterized by a rather bizarre event in which two jockeys literally fought each other to the finish line. While rough riding was not uncommon during the early days of racing, this event was out of the ordinary. Don Meade on Brokers Tip and Herb Fisher on Head Play were neck and neck in the final stretch. As the two approached the finish line, the jockeys hit and clawed at each other in an effort to finish first. The moment was caught on film by Wallace Lowry, a photographer for the *Courier-Journal*, who had positioned himself at a prime vantage point—on the ground under the inside rail at the finish line. The resulting photograph, and Brokers Tip's Derby win, became known as the "Fighting Finish."

At that time, close races were not yet determined by "photo finishes." It was nearly impossible to the naked eye to determine which horse had won the race. It would be decided by Churchill Downs's team of stewards, who later determined that Brokers Tip had won by a nose. Some, including Fisher, felt that this decision was influenced by the fact that Brokers Tip was the entry of Colonel Edward Riley (E.R.) Bradley, perhaps the most successful horse breeder in Kentucky at that time. Bradley had won the Kentucky Derby with Behave Yourself in 1921, Bubbling Over in 1926 and Burgoo King in 1932. (The names of Bradley's horses always began

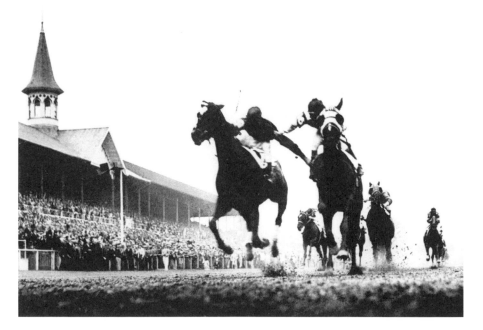

The "Fighting Finish" of 1933 captured on film by Wallace Lowry. *Photo © the* Courier-Journal.

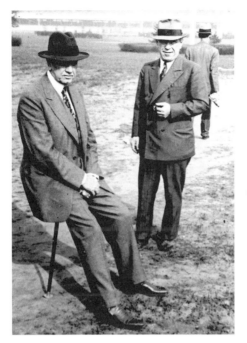

E.R. Bradley (left), owner of several Derby winners, with trainer Dick Thompson at Churchill Downs. *Special Collections, Epsom Library, University of Louisville.*

with the letter "B.") Bradley was also known as a heavy bettor who did not mind wagering large sums of money on his horses. Since he had won the previous year with Burgoo King, Bradley's win with Brokers Tip marked the first back-to-back Derby victory by an owner.

The brawl between the two jockeys continued after the race, as Fisher complained that Meade had fouled him in the stretch. According to Meade, Fisher "attacked" him in the jockeys' room. Meade was suspended for thirty days, while Fisher was suspended for thirty-five. While the two jockeys served their suspensions, Head Play went on to win the Preakness Stakes with jockey Charles Kurtsinger in the irons.

Reportedly, it took thirty-two years for Fisher and Meade to shake hands. According to a 1993 *Sports Illustrated* article, Fisher had earlier recalled, "I hit him across the head with my whip once or twice before the finish and once after. He switched his hold from the saddlecloth to my left shoulder and all but pulled the reins out of my hands. He was holding on to me, and I was pulling him." Meade responded, "He hit me with the whip after the finish, but not before. His reins were dangling perhaps the last sixteenth of a mile. If he'd just ridden his horse, he'd have won by two or three lengths."[31] In any case, thanks to Wallace Lowry's photo, the "Fighting Finish" has become a part of Churchill Downs's rich history. Visitors to Churchill Downs may pay tribute to Brokers Tip, who is buried in the courtyard outside of the Kentucky Derby Museum.

As the decade progressed, the Depression began to lift, and wagering resumed at the track. The *Courier-Journal* reported that, prior to Cavalcade's win at the 1934 Derby, "everybody seemed to have a roll of money and a desire to bet it."[32] The following year brought additional coverage to Churchill Downs as Gallant Fox's son, Omaha, captured the Derby and, subsequently, the Triple Crown. Omaha had been sent off as the second

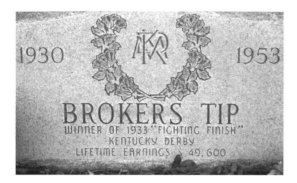

Brokers Tip's grave site. *Courtesy of Allison Pareis.*

choice in the Derby. The favorite was Calumet Farm's filly Nellie Flag and jockey Eddie Arcaro, who was riding in his first Derby. Omaha, a seventeen-hand chestnut, took the lead in the backstretch and ultimately won by 1½ lengths over Roman Soldier. With Omaha's win, Gallant Fox became the first and only U.S. Triple Crown winner to sire a U.S. Triple Crown champion.

The Depression had taken a toll on many of Churchill Downs's early structures, and management opted to begin a restoration project in 1936. In April of that year, the *Herald-Post* reported:

> *The years of the Depression retarded improvements to the extent that many of the buildings gathered dust and dirt and suffered from the ravages of the weather. Today all of Churchill Downs' buildings are clothed in purest white paint, trimmed with green, lending a beautiful picture to the scene, with a background of nature's hills in the offing.*
>
> *Additional seats and boxes have been erected whereby one will be better able to view the running of the races and, at the same time, add to their improvement.*[33]

In January and February 1937, the Ohio River flooded, causing substantial water damage in Louisville. This resulted in an estimated $8,000 worth of damage at Churchill Downs. Crews worked to make necessary repairs in preparation for the upcoming Derby. In its May 10, 1937 issue, *Time* magazine published a feature story on the Derby, with Matt Winn and four Derby contenders prominently displayed on the cover. The article also discussed Louisville's festival celebrating the Derby. While not affiliated with Churchill Downs, the forerunner of Louisville's Kentucky Derby Festival included various parades, pageants and other activities. *Time* reported:

Carpenters working on renovations, circa 1936. *Special Collections, Epsom Library, University of Louisville.*

Last week the amiable, horsey city of Louisville was busy removing traces of the $52,000,000 damage left by last winter's flood in preparation for the one day in the year when it is the sporting capital of the U.S... Louisville this week will provide a program aimed at making this 63rd Derby the noisiest, gayest, most profitable since Depression.

Derby Week starts Wednesday night, with a parade and pageant depicting Kentucky sports, followed by dancing in the streets. Thursday night's specialty this year was to be a tennis match between Ellsworth Vines and Fred Perry at the Jefferson County Armory. Friday night festivities were the Derby Eve Ball, an all-star wrestling program, and the annual reunion banquet & mint-julep shower of Kentucky Colonels. Saturday is the Derby.[34]

View of the crowd at the 1937 Derby. *Library of Congress.*

More than seventy thousand spectators rallied to Churchill Downs on May 8, 1937, to watch Man o' War's son, War Admiral, capture the Derby crown. A stunning brown colt, "the Admiral" was also owned by Samuel Riddle, who had passed up the Derby in 1920 with Man o' War. With the Triple Crown series now firmly established, Riddle brought War Admiral to Churchill Downs. Despite the colt's unwillingness to load into the starting machine (which delayed the race by several minutes), War Admiral dominated the field, leading from wire to wire. Following his Derby win, War Admiral would go on to become the fourth Triple Crown winner in history.

The large crowds that flocked to Churchill Downs each spring mandated the creation of a tunnel connecting the grandstand to the infield. An electronic board that displayed betting odds for the races was also implemented at this time. Matt Winn wrote in his book *Down the Stretch*:

> *Early in 1938, when we knew that the crowd that roams around in the grandstand area was almost causing the walls of the fences to bulge on Derby Day, we decided to lessen the pressure by building a tunnel through to the infield, and a succession of terraces in the infield to take care of the overflow.*
>
> *The infield became a separate unit of the plant. The terraces provided seats for those who wanted to sit, between races, and something to stand on to watch the races. There were separate betting booths in the infield, separate refreshment stands, and all other comforts which the patrons could find in the grandstand area.*[35]

The mint julep became the official signature drink of Churchill Downs in 1938, when it was served in souvenir glasses rather than paper cups. Matt Winn commissioned British-born Harry M. Stevens, the aptly named "King of Sports Concessions," as the concessionaire for

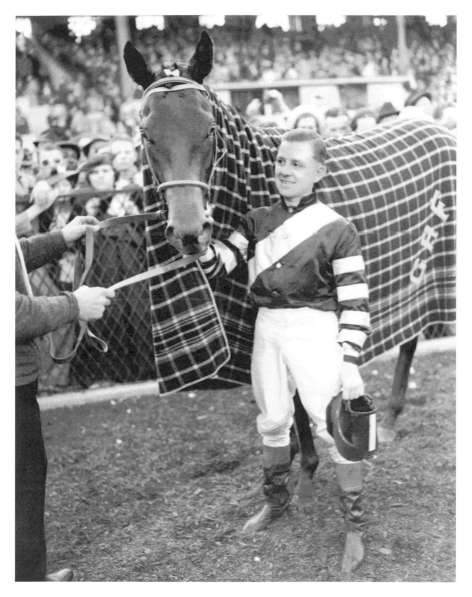

1937 Triple Crown winner War Admiral, shown after winning the Preakness with jockey Charles Kurtsinger. *Courtesy of the Keeneland Library.*

Churchill Downs. (Stevens, incidentally, was credited with introducing the hot dog to baseball.) The first julep glasses were actually used to serve water but were so popular with patrons that they began disappearing from the tables in the dining area. At that time, track managers decided

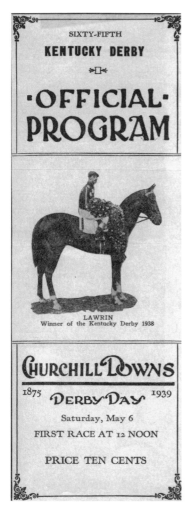

SIXTY-FIFTH
KENTUCKY DERBY

·OFFICIAL·
PROGRAM

LAWRIN
Winner of the Kentucky Derby 1938

CHURCHILL DOWNS
1875 DERBY DAY 1939

Saturday, May 6
FIRST RACE AT 12 NOON

PRICE TEN CENTS

1939 Derby program. *Author's collection.*

to allow patrons to keep the glasses for an additional payment of twenty-five cents per glass. In 1939, the Libbey Glass Co. of Toledo, Ohio, was commissioned by Stevens and Churchill Downs to create an official mint julep glass. The glass, which featured colorful designs, increased sales of mint juleps substantially.

Churchill Downs continued to operate under the auspices of the American Turf Association. Coinciding with the Depression, the association had begun selling off some of its assets. It sold Fairmount Park in 1929, followed by Washington Park and Lexington in 1935; racing at Douglas Park was closed that same year. On January 28, 1937, Churchill Downs and Latonia were merged into Churchill Downs–Latonia Incorporated in an effort to reduce operating expenses. The remaining track, Lincoln Fields, was managed by a separate entity, Lincoln Fields Jockey Club, Inc. The American Turf Association maintained ownership of Churchill Downs, Latonia and Lincoln Fields. In 1938, Matt Winn was named president of Churchill Downs.

By 1939, wagering on Derby Day had returned to its pre-Depression levels. In 1939, the total wagering for the Derby was $584,977. The *Courier-Journal* reported, "If Derby Day is any index, the Depression is long gone."[36] Horse racing, it seemed, was able to give people respite from their financial worries, at least for a moment.

Chapter 5

THE 1940S

WARTIME AND WINNERS

The shadow of World War II during the early 1940s did little to dim the spirits of racing fans. The year 1940 marked the crowning of a new Derby winner, Gallahadion, owned by candy heiress Ethel V. Mars and her Milky Way Farms (named for the chocolate bar). Mrs. Mars had been in strong pursuit of a Derby win, with eight horses entered in a period of six years. During that time, she had two third-place finishes with Whiskolo (1935) and Reaping Reward (1937), but the garland of Derby roses had eluded her.

The overwhelming favorite entering the 1940 Derby was Bimelach, who was expected to bring a fifth Derby crown back to owner E.R. Bradley's farm. Bimelach was the last colt sired by Bradley's famed Black Toney and was fresh off a win in the Derby Trial. The second favorite going into the race was Mioland, the entry of Seabiscuit's owner, Charles Howard. Gallahadion, who had failed to place in both the Santa Anita Derby and the San Juan Capistrano Handicap, was sent off as a 36–1 long shot. While Mrs. Mars remained at home suffering from a head cold, the colt pulled a stunning upset to win the Derby crown for Milky Way Farms.

The year 1940 also marked the introduction of the Bahr electric starting gate at Churchill Downs. The Bahr was the first gate to keep each horse in a separate stall. Bahr starting stalls were first used at Hawthorne Race Course in Chicago in 1928–29. The new starting mechanism was an improvement over the previous barrier starting methods, in which horses often got off to a premature start and had to be caught and restarted with the field. The

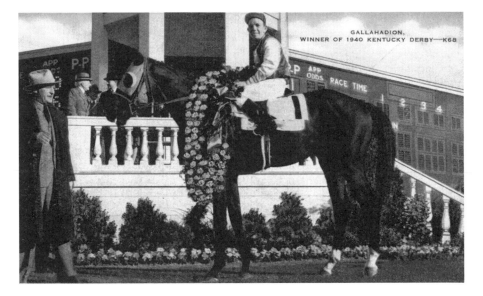

Postcard featuring 1940 Derby winner Gallahadion and jockey Carroll Bierman. *Courtesy of Eric Larson and Cardcow.com.*

gate was also designed to prevent injury to horse and jockey. Additional improvements at the track included a new entrance gate and the relocation of the finish line.

Around this time, there were reports that pieces of glass had been found on the track grounds, most likely due to broken julep glasses. In the interest of safety, Churchill Downs replaced the glass tumblers with aluminum. In the following years, aluminum would be in short supply. At the request of track officials, the Beetleware Company of New York created a ceramic julep tumbler, available in nine colors, for use in 1942, 1943 and 1944. In 1945, the glass tumblers were reintroduced, with three variations: tall frosted, short frosted and a juice glass. Only blank glasses were available in 1946 and 1947 due to production issues, with the decorated glasses returning in 1948.

Whirlaway's 1941 Derby win marked the beginning of Calumet Farm's racing dynasty. The Lexington, Kentucky–based farm would dominate at Churchill Downs over the next two decades, with eight Derby winners and five Oaks winners in the 1940s and 1950s. Calumet Farm was established in 1924 by William Monroe Wright, owner and founder of the Calumet Baking Powder Company; the farm was well recognized for its "devil red" racing silks. Calumet had originated as a standardbred operation, with trotter Calumet

Butler winning the prestigious Hambletonian race in 1931. The farm was converted to a thoroughbred facility in 1932 by Wright's son, Warren Sr. Calumet would be the leading money-earning farm in thoroughbred racing for twelve years, producing two Triple Crown champions and eleven horses that would eventually be inducted into the National Museum of Racing and Hall of Fame.

Whirlaway was one of Calumet's greatest champions; the colt was a stunning chestnut sired by Blenheim II, winner of the 1930 Epsom Derby. Blenheim II had been imported to the United States and, in 1936, was sold for $225,000 to an American syndicate that included top breeders such as Warren Wright (Calumet Farm); Arthur B. Hancock (Claiborne Farm); John D. Hertz (Stoner Creek Stud); William DuPont, Mrs. Thomas H. Somerville and J.H. Whitney (Greentree Stud); and Robert A. Fairbairn (Fairholme Farm). Blenheim II stood at Claiborne Farm in Paris, Kentucky. In addition to Whirlaway, Blenheim II would also sire, among others, 1947 Derby winner Jet Pilot and 1943 Oaks champion Nellie L.

Whirlaway was from Blenheim's first U.S. crop and was known as "Mr. Longtail" due to his lush, flowing tail. Whirlaway was trained by Ben A. Jones and ridden by Eddie Arcaro during his three-year-old season. He was known as one of Calumet's most talented, but difficult, colts. Despite his great speed, the colt lost several races after drifting toward the middle of the track, or "bearing out," a habit that he had developed, presumably, out of boredom. Trainer Ben Jones became highly frustrated, dubbing Whirlaway "a half wit" or a "knucklehead" due to his inability to run in a straight line. In the 1940 Saratoga Special, the colt drifted so far out that he actually crashed into the outer rail, yet he still won the race. He was also prone to bolting and throwing fits.

In preparation for the Derby, Jones created a blinker with a cup for the colt's right eye and removed the corresponding cup from the left eye. This would enable the colt to see straight in front of him and view the inside rail while avoiding the distractions from the grandstand, thus allowing Arcaro to keep the horse from drifting out. The unconventional plan worked, and Whirlaway won the Derby by eight lengths, setting a record for his time of 2:01 $^2/_5$. Whirlaway would return to Churchill Downs to win the Clark Handicap in 1942. (Whirlaway would be ridden by the legendary George "the Iceman" Woolf during most of 1942, while Arcaro served a suspension due to an incident at Aqueduct in New York.)

On January 13, 1942, Churchill Downs–Latonia Incorporated sold the Latonia track. On April 24, the name was officially changed to Churchill

Top: Postcard featuring 1941 Triple Crown champion Whirlaway ridden by Eddie Arcaro. *Courtesy of Eric Larson and Cardcow.com.*

Bottom: Derby crowd, 1942. *Library of Congress.*

Downs Incorporated; the track continued to be affiliated with the American Turf Association. The American Turf Association would sell Lincoln Fields in March 1947.

From 1942 through 1945, many racetracks were shut down by the U.S. Office of Defense Transportation due to gasoline rationing and an order to cease operations of "nonessential recreational facilities." Churchill Downs, however, remained open. In October 1942, Winn allowed the infield to be converted to an area to house four hundred army soldiers and tankers from Fort Knox and Bowman Field. New tents were tested out, and Sherman tanks lined the infield. The area was referred to as "Camp Winn." Churchill Downs raised approximately $120,000 for the Louisville War Fund during this time.

As a result of the war, the 1943 Derby was nearly cancelled. In an effort to conserve rubber and gasoline, automobiles and taxicabs were not allowed within one mile of the racetrack. Despite the travel restrictions, the Derby was held, with only the locals able to attend. As non-locals would be unable to attend the Derby, Winn convinced well-to-do box holders to donate their Derby Day seats to armed forces personnel. The 1943 Derby thus became known as the "Street Car Derby" and, despite its restrictions, was attended by sixty-five thousand spectators. The crowd was not disappointed, as Count Fleet went on to dazzle the crowds and win the Derby en route to capturing the Triple Crown.

Count Fleet, owned by John D. Hertz and his wife, Fannie, was sired by 1928 Derby champion Reigh Count out of a sprint mare named Quickly. Hertz had founded the Yellow Cab Company in 1918 and later developed the "Hertz Drive-Ur-Self System," which would later become the nation's most famous rental car company. John Hertz had purchased Reigh Count as a two-year-old from Willis Sharpe Kilmer, owner of Exterminator. It is reported that Hertz was drawn to Reigh Count after seeing him bite another horse during a race; this led him to believe that the colt was "a fighter," a trait that Hertz admired.

As a foal, Count Fleet proved too much to handle, leading Hertz to offer him up for sale. The colt's misbehavior discouraged any potential buyers, however, and Hertz was forced to keep him. After Count Fleet began racing as a two-year-old and promptly lost his first two starts, Hertz again tried to sell the colt. A stable employee of Hertz's, Sam Ramsen, and jockey Johnny Longden pleaded with Hertz to reconsider, noting that the colt showed tremendous speed. Hertz agreed. Shortly thereafter, wearing Mrs. Hertz's stable colors, Count Fleet broke his maiden.

Count Fleet made his three-year-old debut by winning the St. James Purse, following it up with a victory in the Wood Memorial. In the latter, however, he overreached, causing substantial injury to his left hind leg. It was questionable at this point whether the horse would be able to race in the Kentucky Derby. Traveling to Louisville by rail, jockey Johnny Longden held ice on the colt's injured leg throughout the entire journey.

By Derby Day, Count Fleet was sound and won by three lengths over Blue Swords and Slide Rule. He would go on to win the Preakness and Belmont, becoming the nation's sixth Triple Crown winner. Count Fleet would eventually sire 1951 Derby champion Count Turf.

Even as the war continued to take its toll on the area, Churchill Downs proved beneficial to the Louisville area in many respects. In 1942 and 1943,

the Kentucky State Fair had been cancelled because the State Fairgrounds was being used to produce wartime aircraft parts and shells. The fairgrounds had also been named as one of sixteen rubber collection centers in the country. Matt Winn offered the use of Churchill Downs's infield for the fair, and the annual event was held at Churchill Downs in 1944 and 1945. During 1943 and 1944, the track was also used for the Corpus Christi religious processions, with permission from Colonel Winn. Additionally, when Keeneland Racecourse in nearby Lexington was asked to close temporarily due to the wartime rubber shortage from 1943 to 1946, many of its races were held at Churchill Downs.

In 1944, the Oaks was moved to the Friday preceding the Derby, rather than weeks later, as it had been in years past. According to the *Encyclopedia of Louisville*, local residents had begun to consider Oaks Day as "Louisville's Day at the track," since those who were not able to secure Derby tickets could more easily attend the Oaks. Additionally, the track was already decorated for Derby Day, and locals would be able to enjoy Churchill Downs "decked out in all its Derby finery and flowers."[37]

The 1946 Derby was won by an unlikely candidate, Assault. Despite being the son of 1936 Derby winner Bold Venture, Assault was foaled at King Ranch in Texas, a farm that primarily raised quarter horses and cattle. As a young colt, Assault injured his right front hoof after stepping on a surveyor's stake. As a result, his hoof did not develop properly, and the horse walked with a limp. While galloping, however, the horse was completely sound. Due to his odd-shaped foot and unlikely agility, Assault was nicknamed "the Club-Footed Comet."

In his two-year-old season, Assault won only two races out of nine starts. After winning the Wood Memorial early in his three-year-old season, Assault failed to place in the Derby Trial. However, he would win the Derby by an astounding eight lengths, the largest margin of victory to date. Following his Derby win, he became the seventh Triple Crown winner in history and the third during the 1940s. The decade would ultimately crown four Triple Crown champions: Whirlaway, Count Fleet, Assault and Citation.

The 1948 Derby belonged to Citation (aka "Big Cy"), another Calumet Farm champion. He was trained by Ben A. Jones and his son Horace "Jimmy" Jones and ridden in the Derby by Eddie Arcaro. Citation had been named champion two-year-old, with only one loss that season, to his stable mate, Bewitch. Both were sired by the great Bull Lea.

Citation began his three-year-old season with wins over older horses in the Ground Hog Purse and the Seminole Stakes at Hialeah Park in Florida.

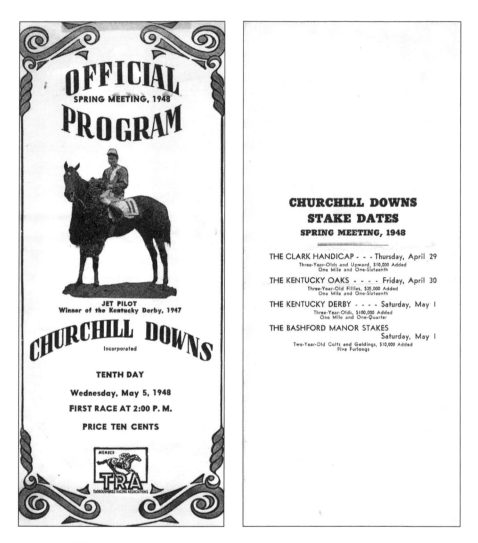

OFFICIAL
SPRING MEETING, 1948
PROGRAM

JET PILOT
Winner of the Kentucky Derby, 1947

CHURCHILL DOWNS
Incorporated

TENTH DAY

Wednesday, May 5, 1948

FIRST RACE AT 2:00 P. M.

PRICE TEN CENTS

MEMBER
TRA
THOROUGHBRED RACING ASSOCIATIONS

CHURCHILL DOWNS
STAKE DATES
SPRING MEETING, 1948

THE CLARK HANDICAP - - - Thursday, April 29
Three-Year-Olds and Upward, $10,000 Added
One Mile and One-Sixteenth

THE KENTUCKY OAKS - - - - Friday, April 30
Three-Year-Old Fillies, $25,000 Added
One Mile and One-Sixteenth

THE KENTUCKY DERBY - - - - Saturday, May 1
Three-Year-Olds, $100,000 Added
One Mile and One-Quarter

THE BASHFORD MANOR STAKES
Saturday, May 1
Two-Year-Old Colts and Geldings, $10,000 Added
Five Furlongs

Above, left: 1948 race program. *Author's collection.*

Above, right: List of race dates from 1948 program. *Author's collection.*

In these races, he defeated, among others, 1947 Horse of the Year Armed (also sired by Bull Lea). Citation then went on to capture the Everglades Stakes and Flamingo Stakes at Hialeah. Following those wins, Citation's regular jockey, Albert "Al" Snider, drowned in a storm while fishing in Florida; his body was never found. Snider was replaced by Eddie Arcaro, who at that point had logged three Derby victories (Lawrin, Whirlaway and Hoop Jr.). Citation, with Arcaro aboard, lost the Chesapeake Trial Stakes

at Havre de Grace racetrack in rural Maryland but rebounded with wins in the Chesapeake Stakes and in the Derby Trial at Churchill Downs on the Tuesday prior to the Derby.

Citation faced his Calumet stable mate, Coaltown, in the Derby, ultimately winning by 3½ lengths. Reportedly, Eddie Arcaro shared his Derby purse with Al Snider's widow. The Calumet entry of Citation and Coaltown paid $2.80, which was the lowest win price in Derby history. Citation would go on to win the Triple Crown and would become the first North American thoroughbred to win sixteen major stakes races in a row. (The great Cigar would duplicate this feat in the 1994–96 period.)

In November 1948, a committee was developed to determine whether it would be feasible for a charitable foundation to be created to purchase Churchill Downs and operate it as a nonprofit organization. All earnings would be donated to the University of Louisville School of Medicine. It would be based on the principles of the Churchill Downs Foundation, a nonprofit organization headed by J. Graham Brown. The foundation had hosted several days of racing at Churchill Downs in the fall, with all proceeds donated to charity. It is estimated that the foundation donated approximately $1.5 million for charitable purposes during the 1940s and '50s.

The decision was still pending on May 7, 1949, when Matt Winn helped celebrate the Seventy-fifth Diamond Jubilee Derby at Churchill Downs. That year, telecasts allowed area viewers to watch the Kentucky Derby on screen for the first time. Winn was interviewed on-site by WAVE television newsman George Patterson as he celebrated this special anniversary race, which was won by Calumet Farm's Ponder (son of the 1944 Derby winner, Pensive). A special "Golden Era" edition of the Derby glass that year featured a portrait of Winn along with the words, "He has seen them all!" Winn had, in fact, witnessed every Derby that was run in his lifetime.

The 1949 Oaks champion was Calumet Farm's Wistful, who defeated nine other fillies to win in 1:47:4. She would later make history by becoming the first to capture National Filly Triple Crown in its earliest incarnation. Born in 1946, Wistful had raced only twice as a two-year-old. In March of her three-year-old season, she defeated colts in the Whirlaway Stakes at Aqueduct Racetrack and, the following month, placed second in the Grade I Ashland Stakes at Keeneland. She would share American Champion Three-Year-Old Filly honors with another great filly, Calumet stable mate Two Lea. As a five-year-old, Wistful

Postcard featuring 1948 Triple Crown champion Citation ridden by Eddie Arcaro. *Courtesy of Eric Larson and Cardcow.com.*

would return to Churchill Downs to overtake the colts and win the Clark Handicap in November 1951 with a time of 1:44:00. It was a particularly impressive victory, as the mare was nearing the end of her racing career and in fact had not been listed as one of the morning-line favorites.

Churchill Downs suffered a tremendous loss with the death of Matt Winn on October 6, 1949, at the age of eighty-nine. Winn's contributions to Churchill Downs were immense. Under his leadership, the Kentucky Derby became the preeminent thoroughbred horse race in America. As a result, Winn was often referred to as the "Father of the Derby." Winn had been honored in his lifetime by Governor Cripps Beckham, being named a Kentucky colonel for his efforts in saving Churchill Downs. At his funeral, Winn's casket was draped with a blanket of roses similar to that which adorns each year's Derby winner.

The present Churchill Downs facility includes numerous reminders of Matt Winn's contributions. The track hosts a race in his honor, the Matt Winn Stakes, which occurs annually in early May. Churchill Downs also holds racing on the Matt Winn Turf Course, which was constructed in 1985, and dinners are held in the Matt Winn Dining Room, located on the third floor of the clubhouse.

Following the death of Matt Winn, William Veeneman was named chairman and chief executive officer of Churchill Downs and the American Turf Association. Bill Corum, a former sportswriter who is credited with the origin of the phrase "Run for the Roses" to describe the Derby, was subsequently appointed as track president. On December 30, 1949, the proposal to purchase Churchill Downs and operate it as a nonprofit operation was permanently tabled. The American Turf Association was dissolved on April 3, 1950, with holders exchanging their shares for stock in Churchill Downs Incorporated.

THE 1950S

THE AGE OF TELEVISION

The 1950s began a new tradition at the Derby with the introduction of a sterling silver julep cup. The cup, introduced by Bill Corum in 1951, measured twelve ounces and featured a horseshoe on the front. That year, the ritual began whereby a toast is made by the governor of Kentucky to the owner of the winning Derby horse. The silver cup is subsequently engraved with the winner's name and added to the official collection housed on-site at Churchill Downs. That year, the Derby was won by Count Fleet's son, Count Turf.

The following year, on May 3, 1952, the first national Derby telecast occurred, with viewers throughout the country able to watch the victory of Hill Gail. The Oaks that year was won by another of Calumet Farm's great fillies, Real Delight. Sired by the great Bull Lea out of the stakes-winning mare Blue Delight, Real Delight sustained a knee injury as a youngster and did not race as a two-year-old. By age three, she had reached a lanky height of seventeen hands. Trained by Ben Jones's son, Jimmy, Real Delight lost only one of her twelve starts, and that loss was by a head at 6½ furlongs. Ridden primarily by Eddie Arcaro, Real Delight's other wins included the Coaching Club American (CCA) Oaks, the Black Eyed Susan Stakes (formerly the Pimlico Oaks), the Ashland Stakes, the Modesty Handicap and the Beldame Stakes. She thus became the second filly (after Wistful) to capture the early version of the Filly Triple Crown.

Between 1952 and 1955, Bill Corum spearheaded several improvements at Churchill Downs. In 1952, the first concrete firewall-based stables were

constructed. The following year, additional seating boxes were constructed in the grandstand, and approximately four hundred third-floor boxes were established in the clubhouse. In 1954, a film patrol system was put into place, allowing officials to watch replays of the races. This was followed by the installation of an automatic sprinkler system that served the entire grandstand and the clubhouse; the estimated cost of the sprinkler system was $300,000. Additionally, in 1954, the official Derby glass was modified to include the names and years of all previous winners, beginning with Aristides in 1875.

With the advent of television, Churchill Downs generated substantial media attention in the weeks leading up to the 1953 Derby. That year, a colt by the name of Native Dancer had emerged as the favorite to win the garland of roses. With his agility, speed and striking color, Native Dancer (nicknamed "the Grey Ghost") took the nation by storm. Undefeated coming into the Derby, the Grey Ghost's come-from-behind style of winning dazzled the crowds.

In preparation for the additional media coverage generated by Native Dancer, part of the grandstand garden at Churchill Downs was converted to a television studio for Derby Day 1953. Native Dancer was sent off at odds of 3–5. At the start of the race, a long shot named Dark Star grabbed the early lead when Native Dancer was bumped by a horse called Money Broker. Dark Star would never relinquish that lead, handing the Grey Ghost his only career loss. Native Dancer would go on to win the Preakness, Belmont and Travers Stakes, a feat accomplished at that time only by three other horses: Duke of Magenta, Man o' War and Whirlaway. It was reported that owner Alfred Vanderbilt later remarked that he would trade all of Native Dancer's other victories for a win in the Derby. Native Dancer's son, Kauai King, would later avenge his sire's one loss, winning the Derby in 1966. Nevertheless, some say that the Grey Ghost still haunts the Churchill Downs facility.

One of the most famous horse-racing rivalries in history occurred at Churchill Downs on May 7, 1955, with the meeting of two great champions: Swaps and Nashua. Swaps, a chestnut, was foaled in California and was owned by Rex Ellsworth, a former cowhand. He was trained by Meshach "Mesh" Tenney, an Arizona native who was viewed as unconventional by the East Coast racing establishment, and ridden by veteran jockey Willie Shoemaker. Nashua was a blood bay owned by millionaire William Woodward Jr.'s famous Belair Stud. He was trained by "Sunny" Jim Fitzsimmons, whose past winners included Triple Crown champions Gallant Fox and Omaha, and ridden by the great Eddie Arcaro.

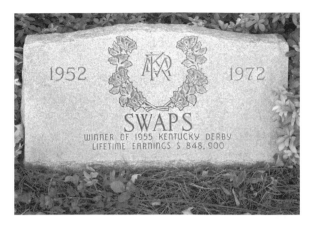

Grave site of Swaps. *Courtesy of Allison Pareis.*

Nashua was sent off as the betting line favorite. Another horse, Summer Tan, would also be in the field of ten on Derby Day. As Summer Tan had previously been Nashua's biggest rival, Arcaro perceived him as the most legitimate threat. Meanwhile, Mesh Tenney was preparing Swaps for the task at hand. According to a *Blood Horse* article, Tenney made sure to introduce Swaps to as much of the Churchill Downs grounds as possible in the days before the Derby; he also played a radio outside of Swaps's stall to prepare the colt for the sounds of Derby Day. Tenney also requested that he be able to walk the colt past the starting gate on the morning of the race so that the horse would not be alarmed by its position.[38] These tactics apparently worked, and despite a late charge by Nashua, Swaps went on to win the 1955 Derby. (The two champions later met in a match race at Washington Park in Chicago on August 31, 1955; Nashua easily won the race.) Visitors to Churchill Downs may visit Swaps's grave, which is located in the garden area next to the graves of several other Derby champions.

The 1957 Derby, which featured a very strong field that included Bold Ruler, Round Table, Gallant Man and Iron Liege, was decided by a rather uncharacteristic error on the part of a jockey. As Gallant Man with Bill Shoemaker and Iron Liege with Bill Hartack passed the sixteenth pole, Shoemaker mistakenly thought that he had crossed the finish line and stood up in the irons, slowing Gallant Man. Shoemaker immediately realized his error; however, it was too late, as Iron Liege and Hartack surged past the Derby finish line and on to victory. Shoemaker would make amends for his error in the coming years, winning, amongst other races, the Kentucky Derby three times.

In 1959, the three-year-old filly Indian Maid earned herself a place in Churchill Downs history when she won the first of three consecutive

Falls City Handicap races. Owned by Mary Keim of Evanston, Illinois, and trained by Howard C. Hoffman, Indian Maid's talent often proved intimidating to her rivals, leading one *Chicago Daily Tribune* reporter to quip, "Only too often, [Indian Maid] has frightened away potential challengers in major races."[39]

The 1950s ended with a change of leadership at Churchill Downs. President Bill Corum died in December 1958 and was replaced on March 3, 1959, by Wathen R. Knebelkamp, a distillery executive, horseman and former owner of the Louisville Colonels baseball team. The business-minded Knebelkamp would make significant improvements to Churchill Downs within the next several years at an estimated cost of $5 million.

Chapter 7

THE 1960S

A TIME OF UNREST

The 1960s was a decade of change at the racetrack, with significant construction underway under the direction of Wathen Knebelkamp. Projects included the addition of the fourth and fifth floors to the Skye Terrace in the clubhouse (known as "Millionaires Row" due to its posh seating and exceptional view), the expansion of the north end of the grandstand by one thousand seats and the construction of new jockeys' quarters. In December 1960, management approved the development of a museum to house Churchill Downs memorabilia. According to the *Courier-Journal*, the idea had been in discussion for close to twelve years.[40] The museum, which would first open in the spring of 1962, displayed numerous Derby and racing artifacts, ranging from the boots worn by Aristides in his Derby victory to an early parimutuel machine.

The decade had begun with rumors of a hostile stock takeover attempt of Churchill Downs. In an effort to avoid outside ownership, officials proposed that the City of Louisville issue revenue bonds to purchase the facility. The proposal was ultimately rejected. The Kentucky Racing Commission responded in December 1963 with a bid to purchase both Churchill Downs and Keeneland Race Course through the establishment of a new entity; this proposal also failed. When a Louisville-based industrial company called National Industries expressed interest in acquiring Churchill Downs in 1969, management and patrons joined forces in an effort to retain ownership. In March of that year, the Derby Protection Group was founded to outbid the prospective purchasers. The group of seven horsemen—which included Arthur "Bull" Hancock, John Galbreath and Warner L. Jones

CHURCHILL DOWNS

THE GREATEST NAME IN RACING

VISIT THE

KENTUCKY DERBY MUSEUM

Jr.—successfully outbid National Industries and retained control of the racetrack. Bidding against National Industries, stock was increased from twenty-two to thirty-five dollars per share.

The 1964 Derby was highlighted by the victory of the Canadian-bred Northern Dancer. The colt was sired by Nearctic out of Natalma, a daughter of "the Grey Ghost," Native Dancer. As a two-year-old, Northern Dancer had captured the Canadian Juvenile Championship, winning seven races in nine starts. He began his three-year-old campaign with Grade I wins in the Flamingo Stakes and the Florida Derby with jockey Bill Shoemaker. However, when given the option to ride the colt in the Derby, Shoemaker opted instead for the West Coast champion Hill Rise. Bill Hartack took over the reins on Northern Dancer, and the pair went on to win the Derby, despite a fast closing run by Shoemaker and Hill Rise. The winning time of 2:00 set a new Derby record. Northern Dancer was also the youngest Derby winner; foaled on May 27, 1961, the colt was not officially three years old when he won the Derby.

Mirroring the radical climate that pervaded the United States, the 1960s were notable for some

Left, top: 1967 museum brochure. *Author's collection.*

Left, bottom: 1962 ticket stubs. *Author's collection.*

out-of-the-ordinary events at Churchill Downs. At the 1965 Derby, a fire broke out in the clubhouse near the first turn, yet many spectators would not leave their seats. While the fire was visible on television broadcasts of the race, damage was minimal. In 1967, in an early race during Derby week, a group of youths holding a protest leaped onto the track and ran in front of several horses. Fortunately, there were no injuries reported in either incident.

In 1968, as attendance at the Oaks continued to rise, the purse was increased to $63,720—the richest in the history of the race thus far. The winner was Dark Mirage, who soared past her rivals by 4½ lengths to win over second-place finisher Miss Ribot. Standing a mere 15.1 hands, Dark Mirage had won only two races in fifteen starts as a two-year-old. She blossomed in her three-year-old season. After losing her first start, she won nine in a row en route to becoming the first winner of the Triple Tiara (formerly known as the Filly Triple Crown). She was also named Champion Three-Year-Old Filly. (Sadly, Dark Mirage would die the following year as a result of complications from a dislocated sesamoid bone, which she sustained while racing in the Santa Margarita Handicap.)

Following Dark Mirage's Oaks victory, Dancer's Image became the first and only Derby winner to be disqualified following the race. A son of Native Dancer, Dancer's Image was eliminated after a post-race urinalysis revealed traces of phenylbutazone in the horse's system. The drug, commonly called "bute," is an analgesic used to relieve inflammation. Apparently, the horse had developed sore ankles during the weeks leading up to the Derby and had been administered the drug by a veterinarian on the Sunday before the race. The drug was legal at many racetracks in 1968 but was prohibited at Churchill Downs.

Peter Fuller, the owner of Dancer's Image, and his various handlers alleged that the horse had been drugged without their knowledge. They filed an appeal with the Kentucky State Racing Commission, which determined that the second-place finisher, Calumet Farm's Forward Pass (who was the pre-race favorite), was the official winner and that his owners should be awarded the Derby cup. This marked the eighth Derby win for Calumet Farm— the most achieved by any one owner.

The story of Dancer's Image's disqualification earned a cover feature in *Sports Illustrated* on May 20, 1968, and in fact was referred to by many as the "sports story of the decade." To this day, Dancer's Image's handlers assert that no wrongdoing occurred and that they were the victims of a setup. Incidentally, Churchill Downs later legalized the use of phenylbutazone when it was found that the drug did not significantly enhance a horse's performance.

Chapter 8

THE 1970S

SECRETARIAT, SLEW AND
A DUEL FOR THE AGES

The decade began with a new track president following the retirement of Wathen Knebelkamp in 1969. Churchill Downs's new president, Lynn Stone, would continue the renovation efforts that Knebelkamp had begun. He had previously served as vice-president and general manager at the racetrack and was thus familiar with its operations. The decade at Churchill Downs would prove to be one of the most exciting in its history. In 1971, a long shot from Venezuela by the name of Canonero II shocked the world with a stellar performance at Churchill Downs. The horse was born in Kentucky with a noticeably crooked foreleg that his handlers felt would limit him from racing successfully. He was sold as a yearling for short money to Edgar Caibett, who subsequently shipped the horse to his native Venezuela. Arriving from abroad for the 1971 Derby, Canonero II was deemed an unlikely prospect and listed as part of a six-horse pool at the bottom of the betting odds. He came from eighteenth place in a twenty-horse field to surge past the leaders and win the Derby by 3¾ lengths. Weeks later, he would go on to win the Preakness Stakes and would earn the Eclipse Award for Outstanding Three-Year-Old Male Horse.

The spring meet of 1972 would witness the Oaks victory of the outstanding filly Susan's Girl. Sired by the 1964 Belmont Stakes winner, Quadrangle, Susan's Girl would win two major races at Churchill Downs. She was the entry of Fred W. Hooper, who previously won the Derby in 1945 with Hoop Jr. As a three-year-old, Susan's Girl won nine out of her thirteen starts and never finished out of the money, earning American Champion

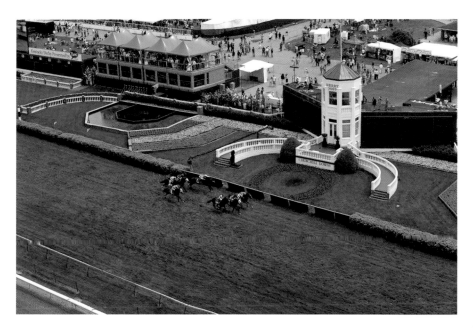

Turf race in front of the winner's circle during Derby week 2009. *Courtesy of Ryan Armbrust/ Sniper Photography.*

The paddock area on Derby Day. *Courtesy of Ryan Armbrust/Sniper Photography.*

The grandstand with its iconic twin spires. *Courtesy of Ryan Armbrust/Sniper Photography.*

View from the stands at dawn. *Courtesy of Ryan Armbrust/Sniper Photography.*

A horse is bathed after a workout. *Courtesy of Ryan Armbrust/Sniper Photography.*

Laundry hangs to dry on the backside. *Courtesy of Ryan Armbrust/Sniper Photography.*

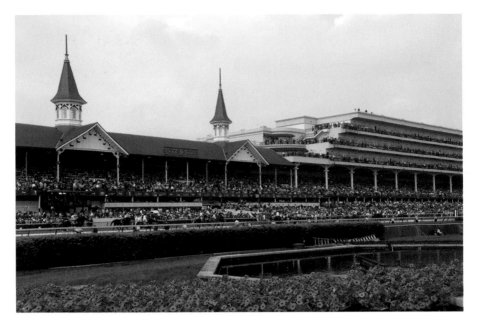

View of the grandstand on Derby Day. *Courtesy of Ryan Armbrust/Sniper Photography.*

The paddock area. *Courtesy of Allison Pareis.*

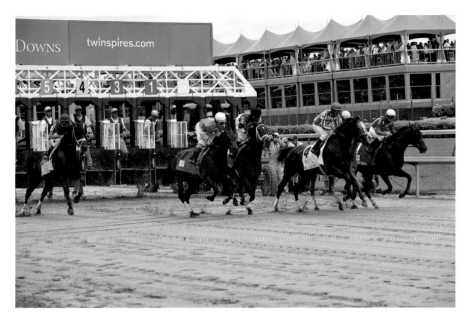

Horses emerge from the starting gate. *Courtesy of Ryan Armbrust/Sniper Photography.*

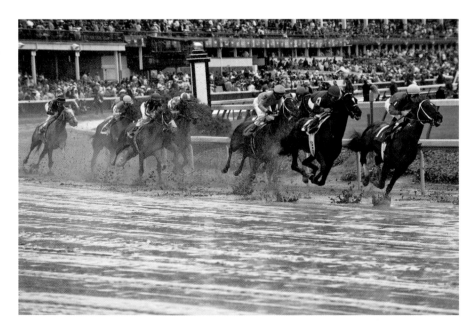

Horses running on a muddy track. *Courtesy of Ryan Armbrust/Sniper Photography.*

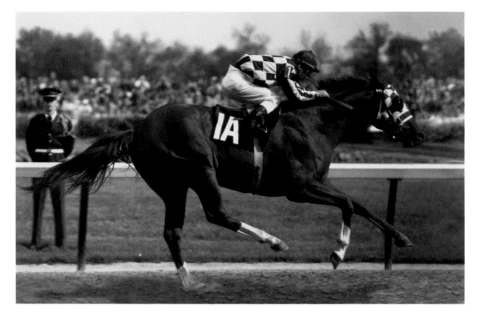

1973 Triple Crown champion Secretariat with jockey Ron Turcotte. *Courtesy of Gallery of Champions.*

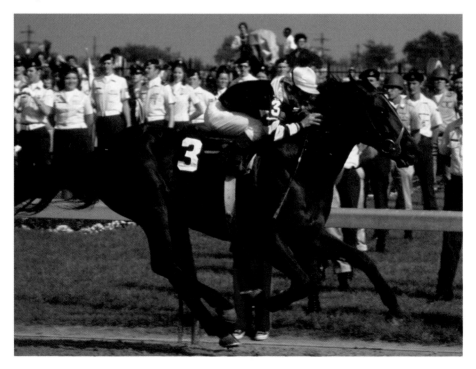

1977 Triple Crown champion Seattle Slew with jockey Jean Cruguet. *Courtesy of Gallery of Champions.*

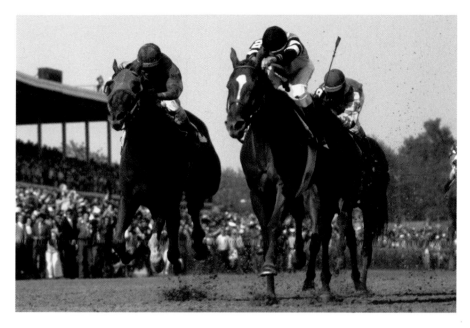

The 1978 Derby victory of Affirmed (**right**) and Steve Cauthen over Alydar and Jorge Velasquez. *Courtesy of Gallery of Champions.*

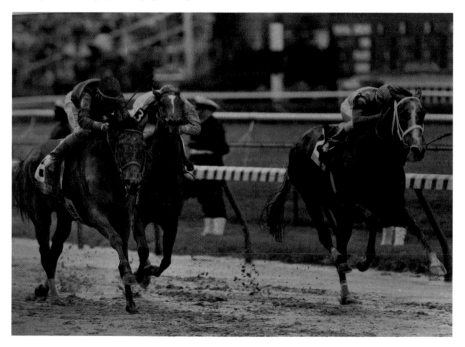

Personal Ensign and Randy Romero (**left**) en route to defeating 1988 Derby champion Winning Colors and Gary Stevens (**right**) in the 1988 Breeders' Cup Distaff. *Courtesy of Gallery of Champions.*

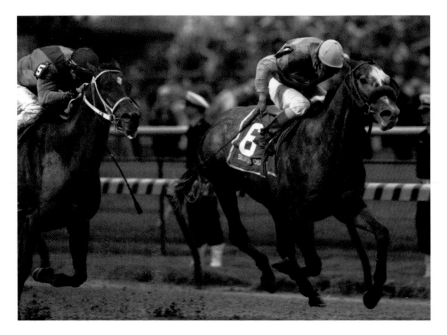

1997 Derby champion Silver Charm with jockey Gary Stevens. *Courtesy of Gallery of Champions.*

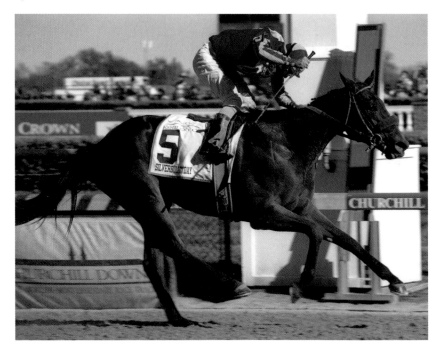

1998 Breeders' Cup Juvenile winner Silverbulletday with jockey Gary Stevens. *Courtesy of Gallery of Champions.*

Summerly, 2005 Oaks champion, is bathed after a workout. *Courtesy of Allison Pareis.*

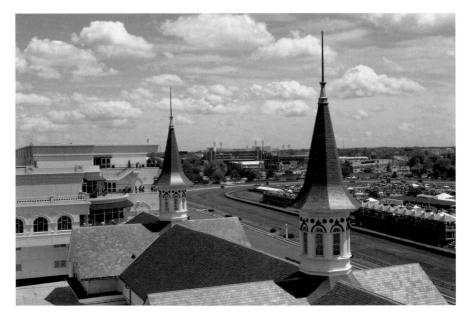

The spires have become the symbol of Churchill Downs. *Courtesy of Ryan Armbrust/Sniper Photography.*

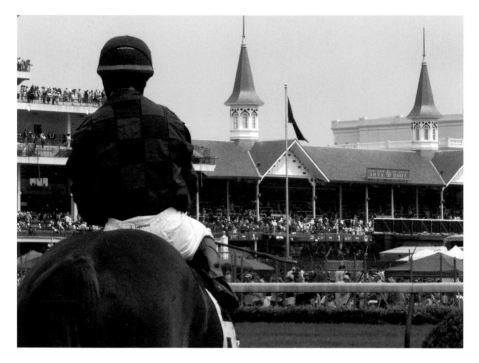

Jockey Julian Leparaoux looks out over the track. *Courtesy of Allison Pareis.*

A display in the Kentucky Derby museum. *Courtesy of Allison Pareis.*

Part of the Pierre Bellocq mural featuring trainer Bob Baffert. *Courtesy of Ryan Armbrust/ Sniper Photography.*

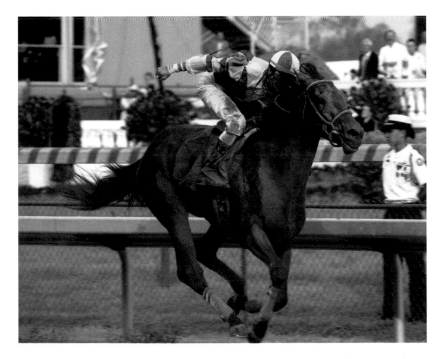

2007 Derby champion Street Sense with jockey Calvin Borel. *Courtesy of Gallery of Champions.*

EIGHT BELLES

She will live in our hearts
The magnificent steel gray
Who gave us her all
The first Saturday in May

- Fox Hill Farm

...ridled's Song - Away, by Dixieland Band
...bruary 23, 2005 - May 3, 2008
...d Place, Kentucky Derby 134

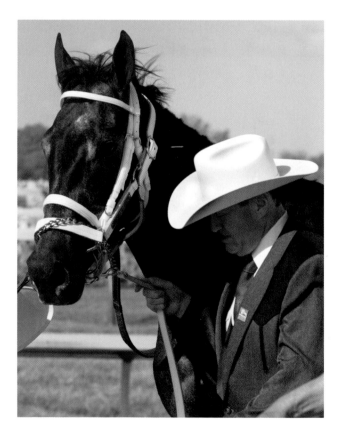

Above: Eight Belles's grave site. *Courtesy of Jessie Holmes/DRF.*

Right: Eight Belles on Derby Day 2008 with trainer Larry Jones. *Courtesy of Allison Pareis.*

Left: Proud Spell, 2008 Oaks champion and stable mate of Eight Belles. *Courtesy of Allison Pareis.*

Below: Barbaro's grave site and statue. *Courtesy of Ryan Armbrust/ Sniper Photography.*

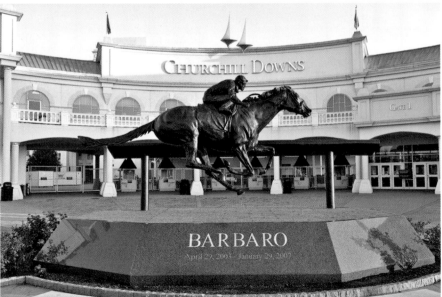

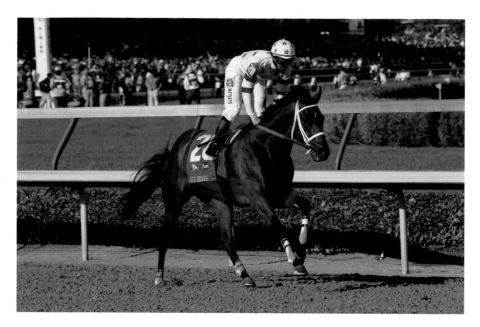

2008 Derby champion Big Brown with jockey Kent Desormeaux. *Courtesy of Ryan Armbrust/ Sniper Photography.*

Einstein, winner of the 2008 Clark Handicap and the Woodford Reserve Turf Classic in 2008 and 2009. *Courtesy of Jamie Newell.*

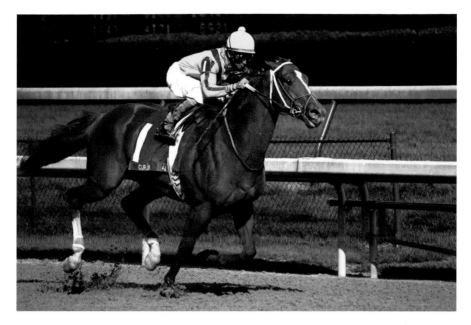

2008 Stephen Foster Handicap winner Curlin with jockey Robby Albarado. *Courtesy of Jamie Newell.*

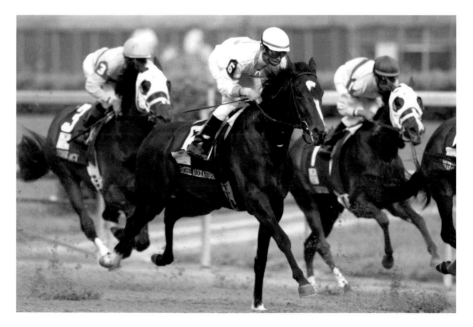

2009 Oaks champion Rachel Alexandra with jockey Calvin Borel. *Courtesy of Jamie Newell.*

2009 Derby champion Mine That Bird with jockey Calvin Borel. *Courtesy of Ryan Armbrust/ Sniper Photography.*

The 2009 Clark Handicap victory of Blame and jockey Jamie Theriot over Misremembered and Einstein. *Courtesy of Allison Pareis.*

1973 Oaks ticket. *Author's collection.*

Three-Year-Old Filly honors. Her victory as a five-year-old in the 1974 Falls City Handicap drew substantial acclaim, as her racing days had appeared questionable due to a serious injury sustained during the previous year. By career end, Susan's Girl had become the only filly at that time to win a three-year-old championship followed by two additional championships as an older female.

Churchill Downs garnered new attention with the emergence of a bona fide superstar in 1973. Like Man o' War, Secretariat had been given the nickname "Big Red" due to his chestnut coloring and massive size. Secretariat had won the attention of racing fans when he was named Horse of the Year as a two-year-old in 1972, a feat commonly achieved by older horses. This followed key wins in the Sanford Stakes and Hopeful Stakes at Saratoga Race Course and the Futurity Stakes at Belmont Park, as well as the Laurel Futurity and the Garden State Futurity. Secretariat was owned by Helen "Penny" Chenery Tweedy of Meadow Stable in Virginia. A son of Bold Ruler out of the mare Somethingroyal, Secretariat was trained by Lucien Laurin and ridden by jockey Ron Turcotte. Together, this owner/trainer/jockey team had won the 1972 Derby with the bay colt Riva Ridge; Meadow Stable appeared poised to capture back-to-back Derby wins. However, after handily winning his first two Derby prep races (the Bay Shore Stakes and the Gotham Stakes at Aqueduct), Secretariat placed a surprising third in the Wood Memorial. Despite this loss, he was sent off as the Derby favorite at odds of 3–2.

The Churchill Downs track was deemed fast on Derby Day, May 5, 1973. The field consisted of thirteen horses, including Santa Anita Derby winner Sham. The race began with Secretariat in last place. Suddenly, Big Red began to make his move through the field of horses, moving up to fifth, fourth and then third behind the leaders, Sham and Shecky Greene. Soon it became a duel between Secretariat and Sham. Big Red kicked it up another notch, completing the last quarter-mile in an astounding 23 seconds and finishing 2½ lengths ahead of Sham. In doing so, he set a new Derby track record, completing the race in 1:59:40—a record that is yet to be broken. Astonishingly, Secretariat ran each quarter-mile segment faster than the prior quarter mile. Secretariat went on to become the first Triple Crown winner in twenty-five years and arguably was one of the greatest horses, if not *the* greatest, in the history of the sport.

Following Secretariat's win, Churchill Downs began preparations for its 100th running of the Derby. Various memorabilia items, including a postage stamp, plates and glasses, were created in honor of the historic anniversary. The race drew 290 nominations and a large field of 23 horses. A record 163,628 spectators were on hand for the victory of Cannonade, a grandson of Bold Ruler, trained by Woody Stephens and ridden by Angel Cordero Jr. In attendance for this special Derby was Her Royal Highness the Princess Margaret of England and her husband, Lord Snowden. The princess participated in the awards presentation, for which a special commemorative Derby trophy had been created.

Meanwhile, construction at the racetrack continued under President Lynn Stone. Significant additions were made to the facility during the next few years, capped off by the addition of the sixth floor to the Skye Terrace in 1977 at an estimated cost of $1.8 million.

In 1977, the excitement of another possible Triple Crown pervaded Churchill Downs with the arrival of the undefeated Seattle Slew. The colt had many obstacles to face on Derby Day, however. As he was led through the paddock area, the colt was startled by the loudness of the band playing the national anthem, followed by a crowd of shouting spectators, some waving banners. The distractions appeared to unnerve the colt, as did the sweltering heat of the day, which caused him to break into a sweat. At the start of the race, Slew banged the gate and then collided with Get the Axe, losing several lengths in the process. The great Slew rebounded, however, catching the leader, For the Moment, at the first quarter mile. As he neared the top of the stretch, Slew took

1974 first day cover honoring the 100th running of the Derby. *Author's collection.*

command, drawing clear of the field and ultimately finishing 1¾ lengths ahead of Run Dusty Run. Seattle Slew would go on to win the Belmont and the Preakness, becoming the tenth Triple Crown winner ever and the second Triple Crown champion of the decade.

The 1978 Derby would forever be remembered for the duel between two great chestnut colts, Affirmed and Alydar. The media often debated as to which colt was better, setting up a showdown for Derby Day. The pair had met six times in the prior season, with Affirmed taking the series 4–2. Affirmed traveled west to prepare for the Derby, winning the Santa Anita Derby, while Alydar moved south to Florida and Kentucky. There, Alydar proved his mettle, winning the Flamingo Stakes and the Florida Derby and capping off his Derby prep with a thirteen-length win in the Bluegrass Stakes. There was no predicting who would prevail on Derby Day.

A crowd of 131,000 was present to watch the two champions duel under the twin spires. Alydar, who was named the slight favorite on Derby Day, would be ridden by Jorge Velasquez; Affirmed would be piloted by eighteen-year-old Steve Cauthen. Nine other horses were entered in the race. As the gates opened, Affirmed ran contentedly in third behind Sensitive Prince and Raymond Earl, while Alydar remained near the back, favoring his come-from-behind style. Alydar made his way through the field as Affirmed remained near the front, never lower than third.

1979 Derby program. *Author's collection.*

Affirmed made his move for the lead on the far turn, with Believe It running second and Alydar moving into third. Alydar rallied at the end, but it was too late to catch the front-running Affirmed, who ultimately bested his rival by 1¼ lengths for the Derby crown. Affirmed went on to become the third horse in the 1970s to capture the Triple Crown. Alydar, a great horse in his own right, would finish second to Affirmed in all three Triple Crown races.

On the heels of Affirmed's win, the grey colt Spectacular Bid drew comparisons to the 1978 champion when he won five stakes races in seven starts as a two-year-old. "The Bid" set a track record in the Laurel Futurity and tied another record at Pimlico in Maryland. Early in his three-year-old season, he won five straight races: the Hutcheson Stakes, the Fountain of Youth and the Florida Derby at Gulftsream Park; the Flamingo Stakes at Hialeah; and the Blue Grass Stakes at Keeneland.

Spectacular Bid entered the 1979 Derby as the favorite. The track, having experienced a rainstorm, was muddy, or "cuppy." Despite such conditions, Spectacular Bid and nineteen-year-old jockey Ron Franklin went on to win by 2¾ lengths over Secretariat's son, General Assembly. Spectacular Bid went on to win the Preakness but was denied the Triple Crown after placing third in the Belmont. Many attribute this loss to the fact that the Bid had stepped on a safety pin on the morning of the race; the pin became embedded in his hoof and subsequently caused infection. Others attributed the third-place finish to poor riding on the part of Franklin. It is interesting to note that no two-year-old champion would win the Kentucky Derby again until Street Sense in 2007.

The 1970s

At this time, Churchill Downs was in the midst of a multiyear renovation project that would include the addition of press boxes, jockey quarters and a newly renovated museum. By 1980, the renovations spearheaded by Wathen Knebelkamp in the 1960s had nearly reached completion. The estimated cost of such improvements was in excess of $10 million.

THE 1980S

GLAMOUR AND GUTS

The year 1980 began with a bang, as Genuine Risk became the first filly to win the Derby since the victory of Regret in 1915. The chestnut mare, owned by Diana Firestone, was the entry of LeRoy Jolley, who had trained 1975 Derby winner Foolish Pleasure. Genuine Risk, ridden by Jacinto Vasquez, would go on to place second in both the Preakness Stakes and the Belmont Stakes, becoming the first filly to finish in the money in all three Triple Crown races.

The early 1980s brought several improvements to Churchill Downs under President Lynn Stone. In 1981, plans were announced to tear down the Churchill Downs museum and construct a new Kentucky Derby Museum at an estimated cost of $5 to $7 million. The parimutuel system was computerized in 1982, and management extended its spring race meet from fifty-five days to ninety-three days. Also in 1982, Churchill Downs created the Stephen Foster Handicap, a 1⅛-mile race named in honor of the composer of "My Old Kentucky Home." The inaugural Stephen Foster Handicap was won by Vodika Collins, who claimed the race for a second time the following year. The race was restricted to horses age four and older in 1983 and from 1985 through 1987. It is now open to three-year-olds as well as older horses.

In 1984, Churchill Downs successfully avoided takeover attempts by Brownell Combs II of Spendthrift Farm and Irwin L. Jacobs. In August of that year, Lynn Stone resigned as president of Churchill Downs. Thomas H. Meeker, an attorney who had previously served as general counsel to Churchill Downs, was named acting president. The following month,

the forty-year-old Meeker was named president, becoming the youngest president of Churchill Downs since M. Lewis Clark.

Meeker began work on a five-year renovation project, which included the construction of the Matt Winn Turf Course in 1985; this important improvement would make Churchill Downs eligible to host the Breeders' Cup Championships, a day of multiple races run on both dirt and turf. Other additions made between 1984 and 1989 included paddock construction, improvements to the barn area and clubhouse and updating the Skye Terrace. The project was estimated at approximately $25 million. In April 1985, the new Kentucky Derby Museum opened its doors, complete with various interactive displays, a cinema and one-of-a-kind racing memorabilia. The following year, in 1986, Churchill Downs was honored by being named a National Historic Landmark.

As in previous decades, new records were set at Churchill Downs in the 1980s, beginning with Genuine Risk's historic win. At the 1986 Derby, Bill Shoemaker became the oldest jockey to win the race at the age of fifty-four. It was Shoemaker's fourth Derby win, and his mount, Ferdinand, had been sent off at 18–1 odds. In May 1988, Winning Colors became the third filly in history to win the Kentucky Derby.

On November 5, 1988, Churchill Downs was ready to host its first Breeders' Cup Championships. The event had been founded by John Gaines of Gainesway Farm in Lexington, whose plan was to hold a day of million-dollar championship caliber races in multiple divisions. The day would include races for various classes of horses and would occur at the end of the fall racing season. Each race would be worth at least $1 million. The Breeders' Cup would be held at different racetracks from year to year and was designed to attract foreign entries as well as those based in the United States. The first Breeders' Cup Championships took place in 1984 at California's Hollywood Park, followed by stints at Aqueduct (1985), Santa Anita (1986) and a return to Hollywood Park in 1987 before making its way to Churchill Downs.

The first Breeders' Cup under the twin spires was defined by a series of grand victories. Miesque became the first two-time winner of a Breeders' Cup race when she won the Mile for the second consecutive year. Having raced primarily in France, the filly won the race by 4 lengths over a strong field of older males that included Belmont Stakes winner Bet Twice. Trainer D. Wayne Lukas achieved one of his greatest feats that day when his Is It True defeated the heavily favored Easy Goer by 1¼ lengths in the Juvenile; it was one of the biggest upsets in the history of the Breeders' Cup. (Easy

Above, left: 1988 Breeders' Cup program. *Author's collection.*

Above, right: The great Alysheba, shown here in later years. *Courtesy of Allison Pareis.*

Goer would go on to lose the Derby to Sunday Silence a mere six months later.) Continuing Lukas's success, Gulch won the Sprint and Open Mind won the Juvenile Fillies.

Two other great moments in Breeders' Cup history occurred that day at Churchill Downs. The four-year-old mare Personal Ensign and jockey Randy Romero made history when they came from four lengths behind to defeat the reigning Derby champion, Winning Colors, by a nose in the Distaff. The mare's effort would be lauded by many as one of the greatest finishes in thoroughbred racing. The 1988 Breeders' Cup will also be forever remembered for the victory of 1987 Derby champion Alysheba, ridden by Chris McCarron, over Seeking the Gold in the Classic. It was Alysheba's third attempt at winning a Breeders' Cup race, following a third-place finish in the Juvenile in 1986 and a loss by a nose to 1986 Derby champion

Ferdinand in the 1987 Classic. Alysheba, the most famous son of Alydar, had become known as "America's Horse" because of his stunning victory over Bet Twice in the Derby after stumbling in the stretch. Back at Churchill Downs for the Breeders' Cup Classic, Alysheba did not disappoint his fans, winning by half a length and securing himself Horse of the Year honors.

Chapter 10

THE 1990S

MOMENTS OF GREATNESS

The Breeders' Cup returned to Churchill Downs in 1991 for a second outstanding day of racing. Arazi, the Champion Two-Year-Old in France, commanded attention with a five-length win in the Juvenile, despite having never raced on dirt. His performance would be praised by the National Thoroughbred Racing Association (NTRA), which later stated that "Arazi turned in what many still consider to be the single-most spectacular performance in Breeders' Cup history."[41]

Arazi, who was racing for the first time in the United States, drew the last post position in the fourteen-horse field. The lead was set by future Eclipse Award winner Bertrando, with Arazi near the back of the pack through the far turn. Arazi and jockey Pat Valenzuela soared through the field of horses, gradually making their way to the front. With three-sixteenths of a mile left, the colt was neck and neck with Bertrando. Galloping past the front-runner, Arazi crossed the finish line seemingly without effort.

In the Breeders' Cup Distaff, Dance Smartly, the only filly to win the Canadian Triple Crown, had an impressive win over Versailles Treaty. In doing so, she became the first horse bred in Canada to win a Breeders' Cup race. In the Turf race, Miss Alleged won at odds of 42–1 over Itsallgreektome, despite having lost her six previous starts in France that season. In the Classic, Ireland's great Black Tie Affair led from wire to wire, soaring past Twilight Agenda and 1990 Derby champion Unbridled for the win.

Excitement returned to Churchill Downs with the 1992 Derby victory by jockey Pat Day; it was Day's first win in ten Derby starts. His mount, Lil

E. Tee, was a long shot who was sent off at 18–1 odds. The front-runner was none other than Arazi. All eyes were on the French colt, whom *Time* magazine had described as "fast winning a reputation as the second coming of Secretariat,"[42] with barely an afterthought given to Day and Lil E. Tee. At the half-mile mark, both horses remained at the back; as Arazi made his signature move through the pack, Lil E. Tee followed. Arazi began to tire as the horses approached the home stretch, and Lil E. Tee made his move past the leaders. Lil E. Tee, who had nearly died as a foal, went on to capture the Derby, giving Day his first and only Derby victory.

At this time, Churchill Downs Incorporated began its expansion as a corporation under President Meeker. The company acquired Calder Race Course in Miami, Florida, in 1991. The following year, the company established a simulcast wagering facility called the Sports Spectrum at the former Louisville Downs harness track. In 1994, Churchill Downs obtained a majority interest in Hoosier Park, a racetrack in Anderson, Indiana, along with several simulcast wagering facilities in that area. The company would subsequently acquire the Kentucky Horse Center, a training facility in Lexington, and Ellis Park Race Course in Henderson, Kentucky, in 1998, and would purchase the California-based Hollywood Park Race Track and Casino in 1999.

The Breeders' Cup returned for a third time to Churchill Downs in 1994. Highlights of the day's races included wins by Pat Day in both the Juvenile and Juvenile Fillies aboard Timber Country and Flanders, respectively. The Juvenile Fillies win was particularly noteworthy, as Flanders out-dueled stable mate Serena's Song to win by a head, despite suffering what was to be a career-ending injury. (Serena's Song would later become the all-time leading female money winner.) In the Distaff, One Dreamer won by a neck over the favorite, Heavenly Prize, and jockey Mike Smith captured wins in both the Sprint (aboard Cherokee Run) and the Turf (aboard Tikkanen). The day was capped off in dramatic fashion, with jockey Jerry Bailey piloting Concern to a stunning last-to-first win over Tabasco Cat in the Classic.

By 1995, there had been a substantial increase in visitors to Churchill Downs. In 1996, the Kentucky Oaks became the second-largest attended race (behind the Derby), with 91,930 spectators. The Derby continued to draw spectators to witness what was now widely regarded as "the most exciting two minutes in sports." In the spring of 1997, steeplechase racing returned to Churchill Downs for the first time since the early 1900s when the $100,000 Hard Scuffle Steeplechase was added to the schedule.

1994 Breeders' Cup ticket. *Author's collection.*

In 1997, the colt Silver Charm and jockey Gary Stevens dazzled the crowd with a captivating Derby win in a field of thirteen starters. Trained by Bob Baffert, Silver Charm was sent off at odds of 4–1, the second choice behind Captain Bodgit. Silver Charm and Stevens would go on to win the Preakness but would be defeated by Touch Gold in the quest for the elusive Triple Crown, which had not been won since Affirmed in 1978. Baffert, along with fellow trainers D. Wayne Lukas and Nick Zito, would dominate the Derby winner's circle at Churchill Downs during the 1990s, collectively winning seven Derby crowns during that decade. Baffert would come close to winning the Triple Crown again in 1998, this time with Real Quiet, only to be defeated by a nose by Victory Gallop in the Belmont. Thunder Gulch's 1995 Derby and Belmont wins combined with his stable mate Timber Country's win in the Preakness the same year gave trainer D. Wayne Lukas the singular honor of taking the three races with different horses.

Silver Charm returned to Churchill Downs in 1998 for the Breeders' Cup Classic under the twin spires. The field for the 1998 Classic was considered by many to be the strongest to date, with starters including Skip Away, Victory Gallop, Swain, Coronado's Quest and Belmont winner Touch Gold. The race would ultimately be won by the Canadian-born Awesome Again, with Silver Charm placing second and Swain a respectable third. (Weeks later, Silver Charm would win the 1998 Clark Handicap at Churchill Downs.) Other key wins at the 1998 Breeders' Cup included Da Hoss, who won the Mile by a head over Hawksley Hill. Da Hoss, who had won the 1996 Breeders' Cup Mile, was sent off at 11–1 odds after having only one start in the past two years due to an injury. He would become the first horse to win two Breeders' Cup races in nonconsecutive years. That same day, the Bob Baffert–trained Silverbulletday earned a

name for herself with a key win in the Juvenile Fillies with Gary Stevens aboard. Silverbulletday had begun her two-year-old career with an eleven-length maiden win, followed by a victory at Churchill Downs in the Debutante Stakes. In 1999, the filly would return to Churchill Downs and dominate the Oaks field of seven starters, winning over Dreams Gallore and Sweeping Story in 1:49:92.

That same year, the Bob Baffert–trained filly Chilukki set the first of her two track records at Churchill Downs, blazing through 4½ furlongs at fifty-one seconds flat in her maiden outing. That year she also won the Debutante Stakes at Churchill Downs, winning by a length over the fast-running Spain. Chilukki would set another track record the following year in the one-mile Churchill Downs Distaff Handicap. In her honor, this race would be renamed the Chilukki Stakes. Sadly, Chilukki would die from complications sustained during foaling in 2007.

In 1999, Alexander Waldrop became the eleventh president of Churchill Downs, replacing Thomas Meeker. The decade closed in dramatic fashion with Charismatic's win in the 1999 Derby. Trained by D. Wayne Lukas, Charismatic had been passed over by several jockeys, including Jerry Bailey, Laffit Pincay, Chris McCarron and Mike Smith, before Chris Antley finally agreed to ride him. Antley was familiar with the track, having won the 1991 Derby on Strike the Gold, but had been away from the scene for a few years while fighting a battle with substance abuse. Charismatic was sent off as a 31–1 long shot on Derby Day and went on to win the race over Menifee and Cat Thief, proving that in horse racing, anything is possible. Charismatic would go on to win the Preakness but sustained an injury in the Belmont while finishing third. Many believe that Antley's efforts saved Charismatic's life when he hopped off and held the horse's injured leg until veterinarians arrived. (The horse went on to recover, but Antley sadly died the following year.)

The quest for the Triple Crown would continue into the new millennium.

THE NEW MILLENNIUM

BARBARO AND BEYOND

The year 2000 marked the third century in which Churchill Downs offered live horse racing. The Breeders' Cup returned to the twin spires in November for another day of world-class racing. It was a day in which the non-favorites prevailed. The mare Spain, sent off at 56–1 odds, shocked the crowd with a victory over the heavily favored Ribolletta in the Distaff, paying $113.80 to win. (Two years later, Spain would return to Churchill Downs, winning the Louisville Stakes.) In the Classic, Tiznow battled with Albert the Great for the first mile; when Albert the Great tired, Tiznow dueled to the finish with Ireland's "Iron Horse," Giant's Causeway. Tiznow won by a neck in what many regard as one of the greatest matches in the history of the Breeders' Cup Classic. The much-heralded Fusaichi Pegasus, who had won the Derby months earlier, finished a disappointing sixth. Tiznow would go on to repeat as champion the following year, becoming the first two-time Breeders' Cup Classic winner.

In 2002, Steve Sexton was named president of Churchill Downs. That year, the track began the first phase of its proposed $121 million renovation project. Phase I, which would be completed in the fall of 2003, included the addition of sixty-four luxury suites and meeting areas above the grandstand. The second phase of the project, lasting from 2003 to 2005, would add 404,000 square feet of space, indoor box seats, outdoor third-floor boxes, an expansion of the Turf Club area, a new media center and new entertainment, kitchen and dining facilities. The track was renovated, along with the clubhouse and its iconic twin spires, and a new

Spain, winner of the 2000 Breeders' Cup Distaff. *Courtesy of Allison Pareis.*

entrance at Gate 17 led to the track's simulcast wagering areas. In the upper clubhouse, a large, brightly colored mural by horse racing cartoonist Pierre "Peb" Bellocq featured the likenesses of each of the jockeys who have won the Kentucky Derby since 1875. A similar mural featuring the winning trainers was later created.

During the construction period, Churchill Downs Incorporated continued its acquisitions and divestitures. In September 2000, the company merged with Arlington Park in Chicago, Illinois; this would be followed by the acquisition of Fair Grounds Race Course in Louisiana in 2004. Churchill Downs Incorporated sold Hollywood Park in 2005, followed by the sale of Ellis Park in 2006.

New excitement was generated in the period from 2002 through 2004, beginning with the Derby victory of War Emblem. Fans had been waiting for a new Triple Crown champion since Affirmed, and while several horses had come close in recent years, none had been able to win the string of three races. In 2002, War Emblem and jockey Victor Espinoza won the Derby despite the fact that Espinoza had never set eyes on the horse until the morning of the race. The pair went on to win the Preakness but lost the Belmont after War Emblem stumbled at the gate and was unable to catch up with the leaders. In 2003, Funny Cide earned legions of fans who

2002 Derby winner War Emblem and Victor Espinoza. *Courtesy of Allison Pareis.*

pinned their Triple Crown hopes on the chestnut gelding. Owned by a group of former high school buddies, Funny Cide quickly became the "people's horse" when he became the first gelding to win the Derby since Clyde Van Dusen's win in 1929. Funny Cide and Jose Santos soared past the favorite, Empire Maker, to win the Derby by 1¾ lengths. Funny Cide went on to win the Preakness but, like War Emblem, was unable to secure a victory

in the Belmont. The following year, the then-undefeated colt Smarty Jones brought "Triple Crown mania" to new heights when he won the Derby by 2¾ lengths under the guidance of jockey Stewart Elliott. Smarty Jones appeared on the cover of *Sports Illustrated* as fans hoped that he would be the next Triple Crown contender. After winning the Preakness, however, Smarty finished second in the Belmont, following in the steps of his predecessors who had fallen short of winning the Triple Crown.

In 2005, as Oaks attendance continued to rise, the race was honored with its first official glass. The Libbey Company produced a limited number of 7,200 glasses during the first year; in response to demand, production was subsequently expanded to 50,000. The 2005 Oaks was won by the chestnut filly Summerly, who topped a seven-horse field to win by two lengths. The following day, a grey colt by the name of Giacomo shocked the world when he and jockey Mike Smith captured the Derby at 50–1 odds. Giacomo, named for the son of rock legend Sting, became the longest shot to win the Derby since Donerail in 1913. He was owned by Jerry Moss of A&M Records, who would later earn fame as the owner of the champion mare Zenyatta.

On November 12, 2005, Churchill Downs hosted a celebration in honor of retired jockey Pat Day; the event was fittingly referred to as "Pat's Day." Day had begun riding at Churchill Downs's spring meet in 1980 and, according to the *Blood Horse*, promptly lost a string of 14 races.⁴³ Since that time, he had achieved a track record of 2,481 wins, including 155 stakes races and 34 riding titles at Churchill Downs. On June 20, 1984, Day was victorious in a record 7 races. He topped 6 races in a single day on four separate occasions and won 5 races in a single day at Churchill Downs an astounding twenty-one times. On October 29, 2006, Churchill Downs unveiled a bronze statue of Day that now stands in the courtyard near the Aristides monument. It was sculpted by Louisville artist Raymond Graf and depicts Day standing and celebrating his 1992 Derby victory.

The spring of 2006 brought new attention to Churchill Downs with the emergence of its newest Oaks and Derby champions. In the Oaks, the filly Lemons Forever became the longest shot to win the race at odds of 47–1. The Derby was won by Barbaro, who had arrived at Churchill Downs undefeated. A son of Dynaformer out of the mare La Ville Rouge, Barbaro had not raced in the five weeks prior to the Derby. He was trained by Michael Matz, a former Olympic rider, and was owned by Roy and Gretchen Jackson.

Barbaro's tale was one of triumph that would quickly turn to tragedy. He entered the Derby at wagering odds of 6–1, with 3–1 Brother Derek as the

Left: Statue of Pat Day. *Courtesy of Ryan Armbrust/Sniper Photography.*

Below: 2006 Oaks winner Lemons Forever and Mark Guidry. *Courtesy of Chad B. Harmon.*

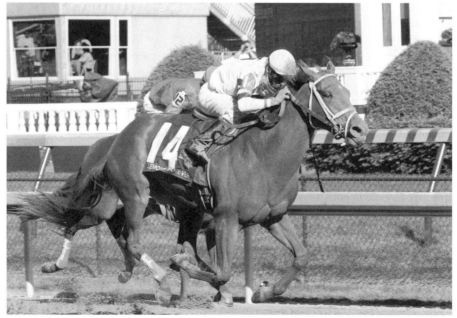

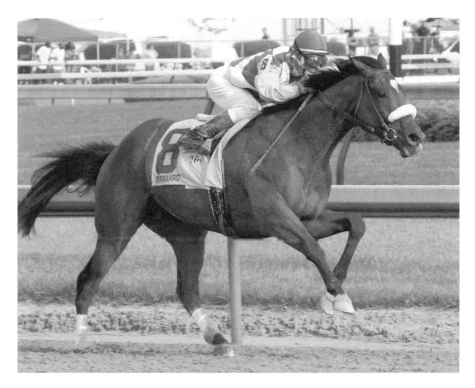

2006 Derby champion Barbaro and Edgar Prado. *Courtesy of Chad B. Harmon.*

morning-line favorite. Ridden by jockey Edgar Prado, Barbaro captured the Derby by 6½ lengths; it was the widest margin of victory since Assault won by 8 lengths in 1946. Regal and handsome, Barbaro became the nation's newest hope for a Triple Crown.

Following his Derby win, Barbaro entered the Preakness as the favorite. He broke from the starting gate early, was examined and reloaded and then broke cleanly with the pack. However, as the horses rallied past the grandstand, Barbaro suffered a catastrophic injury to his right hind leg. Jockey Edgar Prado pulled him up and dismounted as track personnel assessed the horse's injuries. Barbaro was transported to the University of Pennsylvania's New Bolton Center in Kennett Square, Pennsylvania, to be treated by renowned surgeon Dr. Dean Richardson. X-rays revealed that Barbaro's leg had been broken in more than twenty places, and he was given a 5 to 50 percent chance of survival. On the following day, Barbaro underwent surgery in which twenty-seven screws were inserted into his leg in an effort to repair the injuries. While he initially appeared to respond well to the surgery, the

colt developed an abscess in his left foot in early July. By mid-month, he had developed severe laminitis, an inflammation of the delicate structures of the foot, in the left hoof.

The next several months were characterized by a series of highs and lows, with signs of improvement offset by the need for additional procedures. In late January 2007, Barbaro's front legs began to show signs of painful laminitis. With no end to his pain in sight, Barbaro was euthanized on the morning of January 29, 2007, at the request of his owners.

On January 29, 2008, it was announced that Barbaro's cremated remains would be interred in front of an entrance to Churchill Downs and that a bronze statue of Barbaro, created by equine sculptor Alexa King, would be placed atop his remains. The memorial was unveiled at Churchill Downs on April 26, 2009, with Roy and Gretchen Jackson, Edgar Prado and Michael Matz in attendance. It was reported that the Jacksons chose to place Barbaro's remains outside of the gates at Churchill Downs so that fans would be allowed to pay their respects to the Derby champion without having to pay an admission fee.

While Barbaro was at the New Bolton Center, the Breeders' Cup Championships returned to Churchill Downs in November 2006 for an unprecedented sixth time. Once again, records were set under the twin spires. In the Juvenile, the 15–1 Street Sense and Calvin Borel soared past their rivals in a ten-length win over Circular Quay and Great Hunter. Street Sense would return to Churchill Downs to win the 2007 Derby. In the Juvenile Fillies, Dreaming of Anna went wire to wire, easily winning over Octave and Cotton Blossom. The mare Ouija Board, arriving from Great Britain, regained the Filly & Mare Turf crown that she had previously won in 2004. In other victories, Barbaro's team of Michael Matz and Edgar Prado captured the Distaff with Round Pond, and the European Invasor won the Classic over Bernardini and Premium Tap. The latter would go on to set a speed record in the Clark Handicap later that month with a winning time of 1:47:39.

At the end of the fall meet of 2006, Churchill Downs hosted a retirement ceremony for the great horse Cigar. Jockey Jerry Bailey hopped aboard the horse and galloped along the Churchill Downs track before trotting the stallion over to the winner's circle. Cigar was paraded for the crowds between the seventh and eighth races that day. A similar ceremony would be held in November 2008 for North America's first $10 million earner, two-time Horse of the Year Curlin. After placing third in the Derby in 2007, Curlin went on to win the Preakness and placed a close second behind Oaks winner

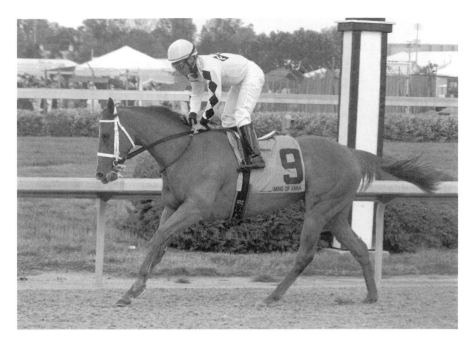

Dreaming of Anna, winner of the 2006 Breeders' Cup Juvenile Fillies, shown here in another race at Churchill Downs. *Courtesy of Allison Pareis.*

Rags to Riches in the Belmont. Curlin won the Stephen Foster Handicap at Churchill Downs on June 14, 2008.

The horse-racing industry had barely recovered from the death of Barbaro when tragedy struck at Churchill Downs. Eight Belles, a grey filly by Unbridled's Song, broke down shortly after placing second behind Big Brown in the 2008 Kentucky Derby. She sustained compound fractures in both front ankles. Due to the severity of her injuries, Eight Belles was immediately euthanized on the track. Her death was the first fatal injury in the history of the Kentucky Derby.

With a name inspired by the late artist N.C. Wyeth, Eight Belles first caught the eye of racing fans in the spring of 2008 when she won the Martha Washington Stakes, the Honeybee Stakes and the Fantasy Stakes. Eight Belles's margin of victory in the Martha Washington Stakes was a record 13½ lengths. In the Derby, she topped a field of eighteen colts, with only Big Brown finishing ahead of her. Denis of Cork finished third, 3½ lengths behind the filly. The previous day, Eight Belles's stable mate, Proud Spell, had won the Kentucky Oaks.

Eight Belles's heartbreaking death brought a rash of negative publicity to Churchill Downs and the sport in general. Radical animal rights groups held protests in the name of Eight Belles and other horses that had died due to racing injuries. At necropsy, Eight Belles was not found to have any illegal drugs in her system, and tests revealed nothing out of the ordinary. It was simply a tragic accident. Nevertheless, the horse-racing community was dealt a harsh blow. Sally Jenkins, a veteran sportswriter for the *Washington Post*, blamed the thoroughbred industry, stating that the filly "ran with the heart of a locomotive, on champagne-glass ankles," and quipped that "thoroughbred racing is in a moral crisis, and everyone now knows it."[44]

Churchill Downs responded with the announcement that safety measures for horses would be greatly enhanced at its various racetracks. While the standards would be improved at all of the tracks owned by Churchill Downs Incorporated, the historic Louisville track was the first to become accredited under the new safety standards. The track surface would undergo performance testing using a robotic hoof device, and horses would be tested for more than one hundred performance-enhancing drugs. A ban on front "toe grabs" on horseshoes, which many believe can contribute to injury, would be instituted. Other modifications included extra foam padding on starting gates and additional restrictions on whipping of the animals. The president and CEO of the National Thoroughbred Racing Association (and former Churchill Downs president), Alex Waldrop, stated that such efforts showed an "unprecedented level of commitment" from Churchill Downs. Later that year, it was announced that the Breeders' Cup Championships would return to Churchill Downs for the seventh time in 2010.

On September 7, 2008, Churchill Downs held a memorial service for Eight Belles. It was attended by more than two hundred well-wishers, including the filly's owners, Rick and Betsy Porter of Fox Hill Farm, and trainer Larry Jones. Eight Belles's remains were interred in the garden area outside of the Kentucky Derby Museum, near the final resting place of Derby champions Swaps, Carry Back, Sunny's Halo and Brokers Tip. A magnolia tree was planted in Eight Belles's honor, with a plaque that reads: "She will live in our hearts/The magnificent steel gray/Who gave us her all/The first Saturday in May." In 2009, the La Troienne Stakes, an annual Grade III race for fillies run on Derby Day, was renamed the Eight Belles Stakes. Prior to the race, the U.S. Navy was on hand to ring eight bells in honor of the fallen champion. The inaugural Eight Belles Stakes would be won by another grey filly, Four Gifts, on May 2, 2009.

Calvin Borel after his 2009 Derby win on Mine That Bird. *Courtesy of Allison Pareis.*

The 2009 Kentucky Oaks brought attention to another outstanding filly that would win the hearts of racing fans at Churchill Downs. Rachel Alexandra, ridden by Calvin Borel, dominated the race, winning by an astounding 20¼ lengths. While many had hoped that the "superfilly" would enter the Derby rather than the Oaks, her then-owners Dolphus Morrison and Michael Lauffer did not like the idea of racing fillies against colts. Following her Oaks win, Rachel was sold to Jess Jackson and Harold T. McCormick, who did not share that belief. (Rachel Alexandra would go on to win the Preakness, the Woodward Stakes and Haskell Invitational that season, en route to capturing Horse of the Year honors.)

One day after Rachel Alexandra's stunning Oaks win, history continued to be made at Churchill Downs. At odds of 50–1, Calvin Borel piloted a plucky bay gelding called Mine That Bird to the Derby winner's circle, tying Giacomo's record as the second-longest shot to win the Derby. Despite being Champion Two-Year-Old in Canada, Mine That Bird had not received much pre-Derby hype; the media was primarily focused on the Baffert-trained colt Pioneerof the Nile, winner of the Santa Anita Derby. Mine That Bird's trainer, Bennie "Chip" Woolley, was a relative unknown who had in fact hauled Mine That Bird from New Mexico to the Derby himself, logging 1,700 miles in a horse trailer attached to a Ford pickup truck. Following the Derby victory, Woolley placed Mine That Bird's garland of roses on the Barbaro memorial as a tribute to the 2006 champion.

The summer of 2009 brought new excitement to Churchill Downs, as night racing was introduced for the first time in the racetrack's history. Three nights of racing were offered in late June and July. The program, called "Downs After Dark," featured specialty cocktails, gourmet dining, a beer garden and live jazz music. Due to the success of its inaugural program, Churchill Downs installed permanent lighting in preparation for night racing in 2010. Also in the summer of 2009, Kevin Flanery was named the thirteenth president of Churchill Downs.

As part of Churchill Downs's renewed focus on entertainment, several concerts were planned. In 2006, the track earned the honor of being the first racetrack to host the Rolling Stones in concert; this was followed by the Police in concert in 2007. Churchill Downs announced that the track would continue to host night concerts, with acts such as Bon Jovi, Kenny Chesney and the Dave Matthews Band scheduled to perform under the twin spires in 2010.

In early August 2009, severe rainstorms resulted in substantial flooding in Louisville. The floods caused management to evacuate horses from at least three barns when floodwaters reached two to three feet in height. Many vehicles parked on the property were submerged. Track workers poured an estimated twenty-five truckloads of track materials on the dirt track in an effort to restore the surface. While horses were able to return to the track within a few days, the flooding resulted in the shutdown of the Kentucky Derby Museum. It would ultimately be closed for more than six months as damages were repaired.

Despite the problems caused by the floods, the track was able to begin its fall racing meet as planned. In November, the Brazilian-born horse Einstein returned to Churchill Downs to defend his Clark Handicap title. In May of that year, Einstein had become the first horse to capture Churchill Downs's Woodford Reserve Turf Classic Stakes twice, with back-to-back wins in 2008 and 2009. Despite making a late charge, the seven-year-old Einstein was unable to win the 2009 Clark Handicap, placing third behind the three-year-old Blame and the Baffert homebred Misremembered.

Capping off a successful year of racing, Churchill Downs celebrated 2009 Derby- and Oaks-winning jockey Calvin Borel with a day of festivities in his honor in November. Borel, a winner of numerous races at Churchill Downs including the Derby in 2007 and 2009, has been nicknamed "Calvin Bo-Rail" due to his signature move of staying close to the inside rail and moving up from behind. Borel is second to Pat Day in career wins at Churchill Downs, with 958 trips to the winner's circle as of November 2009.

As Churchill Downs heads into 2010, new records continue to be set, and heroes, both equine and human, are made. Each year, millions travel from around the world to visit the historic racetrack and gaze on the famed twin spires. Racing fans, concertgoers, families and local folk continue to gather at the place where the dream of a man named M. Lewis Clark first became a reality. It is a place steeped with tradition, with triumph and heartbreak, with pageantry and prestige and, above all, with history. As the *Louisville Herald* reported in 1920: "Derby Day finds beautiful Churchill Downs clothed in

A sign alerts visitors of the closure of the Kentucky Derby museum due to flooding in August 2009. *Courtesy of Ryan Armbrust/Sniper Photography.*

its spring garb all ready to receive the club's guests. The decorative scheme has always been one of Churchill Downs' unique claims to distinction, and this year with the deep green of the centerfield, the glory of the geraniums here and there and everywhere the spick and spanness of every detail, the attention to every comfort, past records are going to fall by the wayside and a new notch be set."[45]

PRESIDENTS OF
CHURCHILL DOWNS

NAME	TERM
Meriwether Lewis Clark Jr.	1975–1894
William Schulte	1895–1901
Charles Grainger	1902–1917
Johnson N. Camden	1918–1927
Samuel Culbertson	1928–1937
Matt Winn	1938–1949
Bill Corum	1950–1958
Wathen Knebelkamp	1959–1969
Lynn Stone	1969–1984
Thomas Meeker	1984–1999
Alex Waldrop	1999–2002
Steve Sexton	2002–2009
Kevin Flanery	2009–present

Appendix B

CHURCHILL DOWNS TRACK RECORDS

As of January 1, 2010

DIRT

DISTANCE	HORSE	AGE	TIME	DATE
4½ Furlongs	Notonthesamepage	2	0:50.12	April 30, 2008
5 Furlongs	Hot Dixie Chick	2	0:56.48	June 13, 2009
5½ Furlongs	Cashier's Dream	2	1:02.52	July 7, 2001
6 Furlongs	Indian Chant	4	1:07.55	July 8, 2007
6½ Furlongs	Love At Noon	3	1:14.34	May 5, 2001
7 Furlongs	Alannan	5	1:20.50	May 5, 2001
7½ Furlongs	Greater Good	4	1:27.97	July 3, 2006
1 Mile	Chilukki	3	1:33.57	November 4, 2000
1¹/₁₆ Miles	Brass Hat	6	1:41.27	July 8, 2007
1⅛ Miles	Victory Gallop	4	1:47.28	June 12, 1999

DISTANCE	HORSE	AGE	TIME	DATE
1³/₁₆ Miles	Bonnie Andrew	5	1:58.60	November 14, 1942
1¼ Miles	Secretariat	3	1:59.40	May 5, 1973
1½ Miles	A Storm Is Brewing	4	2:32.02	June 17, 2001
1⅝ Miles	Tupolev	5	2:49.40	July 23, 1983
1¾ Miles	Caslon Bold	7	2:59.64	July 4, 1995
2 Miles	Libertarian	4	3:22.26	November 28, 1998

TURF

DISTANCE	HORSE	AGE	TIME	DATE
5 Furlongs	Unbridled Sidney	4	0:55.54	July 9, 2005
1 Mile	Jaggery John	4	1:33.78	July 4, 1995
1¹/₁₆ Miles	Wise River	6	1:39.83	April 26, 2009
1⅛ Miles	Lure	4	1:46.34	April 30, 1993
1⅜ Miles	Snake Eyes	7	2:13.00	May 22, 1997
1½ Miles	Tikkanen	3	2:26.50	November 5, 1994

Source: Churchill Downs

KENTUCKY DERBY WINNERS

Year	Horse	Jockey	Trainer	Owner	Time
2009	Mine That Bird	Calvin Borel	Bennie L. Woolley Jr.	Double Eagle Ranch et al.	2:02.66
2008	Big Brown	Kent Desormeaux	Rick Dutrow	IEAH Stables/P. Pompa	2:01.82
2007	Street Sense	Calvin Borel	Carl Nafzger	James B. Tafel	2:02.17
2006	Barbaro	Edgar Prado	Michael R. Matz	Lael Stables	2:01.36
2005	Giacomo	Mike E. Smith	John Shirreffs	Jerry & Ann Moss	2:02.75
2004	Smarty Jones	Stewart Elliott	John Servis	Someday Farm	2:04.06
2003	Funny Cide	Jose Santos	Barclay Tagg	Sackatoga Stable	2:01.19
2002	War Emblem	Victor Espinoza	Bob Baffert	Thoroughbred Corp.	2:01.13
2001	Monarchos	Jorge F. Chavez	John T. Ward Jr.	John C. Oxley	1:59.97
2000	Fusaichi Pegasus	Kent Desormeaux	Neil Drysdale	Fusao Sekiguchi	2:01.00

Year	Horse	Jockey	Trainer	Owner	Time
1999	Charismatic	Chris Antley	D. Wayne Lukas	Bob & Beverly Lewis	2:03.20
1998	Real Quiet	Kent Desormeaux	Bob Baffert	Michael E. Pegram	2:02.20
1997	Silver Charm	Gary Stevens	Bob Baffert	Bob & Beverly Lewis	2:02.40
1996	Grindstone	Jerry Bailey	D. Wayne Lukas	Overbrook Farm	2:01.00
1995	Thunder Gulch	Gary Stevens	D. Wayne Lukas	Michael Tabor	2:01.20
1994	Go for Gin	Chris McCarron	Nick Zito	Condren & Cornacchia	2:03.60
1993	Sea Hero	Jerry Bailey	MacKenzie Miller	Rokeby Stables	2:02.40
1992	Lil E. Tee	Pat Day	Lynn S. Whiting	W. Cal Partee	2:03.00
1991	Strike the Gold	Chris Antley	Nick Zito	BCC Stable	2:03.00
1990	Unbridled	Craig Perret	Carl Nafzger	Frances A. Genter	2:02.00
1989	Sunday Silence	Pat Valenzuela	Charlie Whittingham	H-G-W Partners	2:05.00
1988	Winning Colors	Gary Stevens	D. Wayne Lukas	Eugene V. Klein	2:02.20
1987	Alysheba	Chris McCarron	Jack Van Berg	D. & P. Scharbauer	2:03.40
1986	Ferdinand	Bill Shoemaker	Charlie Whittingham	Elizabeth A. Keck	2:02.80
1985	Spend a Buck	Angel Cordero Jr.	Cam Gambolati	Hunter Farm	2:00.20
1984	Swale	Laffit Pincay Jr.	Woody Stephens	Claiborne Farm	2:02.40
1983	Sunny's Halo	Ed Delahoussaye	David C. Cross Jr.	D.J. Foster Stable	2:02.20
1982	Gato Del Sol	Ed Delahoussaye	Edwin J. Gregson	Hancock & Peters	2:02.40
1981	Pleasant Colony	Jorge Velasquez	John P. Campo	Buckland Farm	2:02.00

Kentucky Derby Winners

Year	Horse	Jockey	Trainer	Owner	Time
1980	Genuine Risk	Jacinto Vasquez	LeRoy Jolley	Diana Firestone	2:02.00
1979	Spectacular Bid	Ronnie Franklin	Bud Delp	Hawksworth Farm	2:02.40
1978	**Affirmed**	**Steve Cauthen**	**Laz Barrera**	**Harbor View Farm**	**2:01.20**
1977	**Seattle Slew**	**Jean Cruguet**	**William H. Turner Jr.**	**Karen L. Taylor**	**2:02.20**
1976	Bold Forbes	Angel Cordero Jr.	Laz Barrera	E. Rodriguez Tizol	2:01.60
1975	Foolish Pleasure	Jacinto Vasquez	LeRoy Jolley	John L. Greer	2:02.00
1974	Cannonade	Angel Cordero Jr.	Woody Stephens	John M. Olin	2:04.00
1973	**Secretariat**	**Ron Turcotte**	**Lucien Laurin**	**Meadow Stable**	**1:59.40**
1972	Riva Ridge	Ron Turcotte	Lucien Laurin	Meadow Stud	2:01.80
1971	Canonero II	Gustavo Avila	Juan Arias	Edgar Caibett	2:03.20
1970	Dust Commander	Mike Manganello	Don Combs	Robert E. Lehmann	2:03.40
1969	Majestic Prince	Bill Hartack	Johnny Longden	Frank M. McMahon	2:01.80
1968	Forward Pass	Ismael Valenzuela	Henry Forrest	Calumet Farm	2:02.20
1967	Proud Clarion	Bobby Ussery	Loyd Gentry Jr.	Darby Dan Farm	2:00.60
1966	Kauai King	Don Brumfield	Henry Forrest	Ford Stable	2:02.00
1965	Lucky Debonair	Bill Shoemaker	Frank Catrone	Ada L. Rice	2:01.20
1964	Northern Dancer	Bill Hartack	Horatio Luro	Windfields Farm	2:00.00
1963	Chateaugay	Braulio Baeza	James P. Conway	Darby Dan Farm	2:01.80
1962	Decidedly	Bill Hartack	Horatio Luro	El Peco Ranch	2:00.40
1961	Carry Back	Johnny Sellers	Jack A. Price	Katherine Price	2:04.00

Year	Horse	Jockey	Trainer	Owner	Time
1960	Venetian Way	Bill Hartack	Victor J. Sovinski	Sunny Blue Farm	2:02.40
1959	Tomy Lee	Bill Shoemaker	Frank E. Childs	Fred & Juliette Turner	2:02.20
1958	Tim Tam	Ismael Valenzuela	Jimmy Jones	Calumet Farm	2:05.00
1957	Iron Liege	Bill Hartack	Jimmy Jones	Calumet Farm	2:02.20
1956	Needles	David Erb	Hugh L. Fontaine	D&H Stable	2:03.40
1955	Swaps	Bill Shoemaker	Mesh Tenney	Rex C. Ellsworth	2:01.80
1954	Determine	Raymond York	William Molter	Andrew J. Crevolin	2:03.00
1953	Dark Star	Hank Moreno	Eddie Hayward	Cain Hoy Stable	2:02.00
1952	Hill Gail	Eddie Arcaro	Ben A. Jones	Calumet Farm	2:01.60
1951	Count Turf	Conn McCreary	Sol Rutchick	Jack J. Amiel	2:02.60
1950	Middleground	William Boland	Max Hirsch	King Ranch	2:01.60
1949	Ponder	Steve Brooks	Ben A. Jones	Calumet Farm	2:04.20
1948	**Citation**	**Eddie Arcaro**	**Ben A. Jones**	**Calumet Farm**	**2:05.40**
1947	Jet Pilot	Eric Guerin	Tom Smith	Maine Chance Farm	2:06.80
1946	**Assault**	**Warren Mehrtens**	**Max Hirsch**	**King Ranch**	**2:06.60**
1945	Hoop Jr.	Eddie Arcaro	Ivan H. Parke	Fred W. Hooper	2:07.00
1944	Pensive	Conn McCreary	Ben A. Jones	Calumet Farm	2:04.20
1943	**Count Fleet**	**Johnny Longden**	**Don Cameron**	**Fannie Hertz**	**2:04.00**
1942	Shut Out	Wayne D. Wright	John M. Gaver Sr.	Greentree Stable	2:04.40
1941	**Whirlaway**	**Eddie Arcaro**	**Ben A. Jones**	**Calumet Farm**	**2:01.40**

Kentucky Derby Winners

Year	Horse	Jockey	Trainer	Owner	Time
1940	Gallahadion	Carroll Bierman	Roy Waldron	Milky Way Farm	2:05.00
1939	Johnstown	James Stout	Jim Fitzsimmons	Belair Stud	2:03.40
1938	Lawrin	Eddie Arcaro	Ben A. Jones	Herbert M. Woolf	2:04.80
1937	**War Admiral**	**Charley Kurtsinger**	**George Conway**	**Glen Riddle Farm**	**2:03.20**
1936	Bold Venture	Ira Hanford	Max Hirsch	Morton L. Schwartz	2:03.60
1935	**Omaha**	**Willie Saunders**	**Jim Fitzsimmons**	**Belair Stud**	**2:05.00**
1934	Cavalcade	Mack Garner	Bob Smith	Brookmeade Stable	2:04.00
1933	Brokers Tip	Don Meade	Herbert J. Thompson	Edward R. Bradley	2:06.80
1932	Burgoo King	Eugene James	Herbert J. Thompson	Edward R. Bradley	2:05.20
1931	Twenty Grand	Charley Kurtsinger	James G. Rowe Jr.	Greentree Stable	2:01.80
1930	**Gallant Fox**	**Earl Sande**	**Jim Fitzsimmons**	**Belair Stud**	**2:07.60**
1929	Clyde Van Dusen	Linus McAtee	Clyde Van Dusen	Herbert P. Gardner	2:10.80
1928	Reigh Count	Chick Lang	Bert S. Michell	Fannie Hertz	2:10.40
1927	Whiskery	Linus McAtee	Fred Hopkins	Harry P. Whitney	2:06.00
1926	Bubbling Over	Albert Johnson	Herbert J. Thompson	Edward R. Bradley	2:03.80
1925	Flying Ebony	Earl Sande	William B. Duke	Gifford A. Cochran	2:07.60
1924	Black Gold	John D. Mooney	Hanley Webb	Rosa M. Hoots	2:05.20
1923	Zev	Earl Sande	David J. Leary	Rancocas Stable	2:05.40

Year	Horse	Jockey	Trainer	Owner	Time
1922	Morvich	Albert Johnson	Fred Burlew	Benjamin Block	2:04.60
1921	Behave Yourself	Charles Thompson	Herbert J. Thompson	Edward R. Bradley	2:04.20
1920	Paul Jones	Ted Rice	Billy Garth	Ral Parr	2:09.00
1919	**Sir Barton**	**Johnny Loftus**	**H. Guy Bedwell**	**J.K.L. Ross**	**2:09.80**
1918	Exterminator	William Knapp	Henry McDaniel	Willis Sharpe Kilmer	2:10.80
1917	Omar Khayyam	Charles Borel	Charles T. Patterson	Billings & Johnson	2:04.60
1916	George Smith	Johnny Loftus	Hollie Hughes	John Sanford	2:04.00
1915	Regret	Joe Notter	James G. Rowe Sr.	Harry P. Whitney	2:05.40
1914	Old Rosebud	John McCabe	Frank D. Weir	Hamilton C. Applegate	2:03.40
1913	Donerail	Roscoe Goose	Thomas P. Hayes	Thomas P. Hayes	2:04.80
1912	Worth	Carroll H. Shilling	Frank M. Taylor	Henry C. Hallenbeck	2:09.40
1911	Meridian	George Archibald	Albert Ewing	Richard F. Carman	2:05.00
1910	Donau	Fred Herbert	George Ham	William Gerst	2:06.40
1909	Wintergreen	Vincent Powers	Charles Mack	Jerome B. Respess	2:08.20
1908	Stone Street	Arthur Pickens	J.W. Hall	C.E. & J.W. Hamilton	2:15.20
1907	Pink Star	Andy Minder	W.H. Fizer	J. Hal Woodford	2:12.60
1906	Sir Huon	Roscoe Troxler	Pete Coyne	Bashford Manor Stable	2:08.80
1905	Agile	Jack Martin	Robert Tucker	Samuel S. Brown	2:10.75
1904	Elwood	Shorty Prior	Charles E. Durnell	Mrs. C.E. Durnell	2:08.50

Kentucky Derby Winners

Year	Horse	Jockey	Trainer	Owner	Time
1903	Judge Himes	Hal Booker	John P. Mayberry	Charles R. Ellison	2:09.00
1902	Alan-a-Dale	Jimmy Winkfield	Thomas C. McDowell	Thomas C. McDowell	2:08.75
1901	His Eminence	Jimmy Winkfield	Frank B. Van Meter	Frank B. Van Meter	2:07.75
1900	Lieut. Gibson	Jimmy Boland	Charles Hughes	Charles H. Smith	2:06.25
1899	Manuel	Fred Taral	Robert J. Walden	A.H. & D.H. Morris	2:12.00
1898	Plaudit	Willie Simms	John E. Madden	John E. Madden	2:09.00
1897	Typhoon II	Buttons Garner	J.C. Cahn	J.C. Cahn	2:12.50
1896	Ben Brush	Willie Simms	Hardy Campbell Jr.	Mike F. Dwyer	2:07.75
1895	Halma	Soup Perkins	Byron McClelland	Byron McClelland	2:37.50
1894	Chant	Frank Goodale	H. Eugene Leigh	Leigh & Rose	2:41.00
1893	Lookout	Eddie Kunze	William McDaniel	Cushing & Orth	2:39.25
1892	Azra	Alonzo Clayton	John H. Morris	Bashford Manor Stable	2:41.50
1891	Kingman	Isaac Murphy	Dud Allen	Jacobin Stable	2:52.25
1890	Riley	Isaac Murphy	Edward Corrigan	Edward Corrigan	2:45.00
1889	Spokane	Thomas Kiley	John Rodegap	Noah Armstrong	2:34.50
1888	Macbeth II	George Covington	John Campbell	Chicago Stable	2:38.00
1887	Montrose	Isaac Lewis	John McGinty	Labold Brothers	2:39.25
1886	Ben Ali	Paul Duffy	Jim Murphy	J.B.A. Haggin	2:36.50

YEAR	HORSE	JOCKEY	TRAINER	OWNER	TIME
1885	Joe Cotton	Babe Henderson	Abe Perry	James T. Williams	2:37.25
1884	Buchanan	Isaac Murphy	William Bird	William Cottrill	2:40.25
1883	Leonatus	Billy Donohue	Raleigh Colston	Chinn & Morgan	2:43.00
1882	Apollo	Babe Hurd	Green B. Morris	Morris & Patton	2:40.00
1881	Hindoo	Jim McLaughlin	James G. Rowe Sr.	Dwyer Bros. Stable	2:40.00
1880	Fonso	George Lewis	Tice Hutsell	J. Snell Shawhan	2:37.50
1879	Lord Murphy	Charlie Shauer	George Rice	Darden & Co.	2:37.00
1878	Day Star	Jimmy Carter	Lee Paul	T.J. Nichols	2:37.25
1877	Baden-Baden	Billy Walker	Edward D. Brown	Daniel Swigert	2:38.00
1876	Vagrant	Bobby Swim	James Williams	William Astor Jr.	2:38.25
1875	Aristides	Oliver Lewis	Ansel Williamson	Hal P. McGrath	2:37.75

Note: Triple Crown winners are denoted in bold text.

KENTUCKY OAKS WINNERS

Year	Horse	Jockey	Trainer	Owner	Time
2009	Rachel Alexandra	Calvin Borel	Hal R. Wiggins	D. Morrison/M. Lautter	1:48.87
2008	Proud Spell	Gabriel Saez	J. Larry Jones	Brereton C. Jones	1:50.01
2007	Rags to Riches	Garrett Gomez	Todd Pletcher	D. Smith & M. Tabor	1:49.99
2006	Lemons Forever	Mark Guidry	Dallas Stewart	L. Willis/T. Horton/Stewart	1:50.07
2005	Summerly	Jerry Bailey	Steve Asmussen	Winchell Thoroughbreds	1:50.23
2004	Ashado	John Velazquez	Todd Pletcher	Starlight Stables et al.	1:50.81
2003	Bird Town	Edgar Prado	Nick Zito	Marylou Whitney Stables	1:48.64
2002	Farda Amiga	Chris McCarron	Paulo Lobo	J. De Camargo et al.	1:50.41
2001	Flute	Jerry Bailey	Robert J. Frankel	Juddmonte Farms	1:48.85
2000	Secret Status	Pat Day	Neil J. Howard	W.S. Farish et al.	1:50.30

Year	Horse	Jockey	Trainer	Owner	Time
1999	Silverbulletday	Gary Stevens	Bob Baffert	Michael E. Pegram	1:49.92
1998	Keeper Hill	David R. Flores	Robert J. Frankel	John A. Chandler	1:52.06
1997	Blushing K.D.	Lonnie Meche	Sam David Jr.	James & Sue Burns	1:50.29
1996	Pike Place Dancer	Corey Nakatani	Jerry Hollendorfer	J. Hollendorfer/G. Todaro	1:49.88
1995	Gal in a Ruckus	Herb McCauley	John T. Ward Jr.	John C. Oxley	1:50.09
1994	Sardula	Ed Delahoussaye	Brian A. Mayberry	Ann & Jerry Moss	1:51.16
1993	Dispute	Jerry Bailey	C.R. McGaughey III	Ogden Mills Phipps	1:52.47
1992	Luv Me Luv Me Not	Fabio Arguello Jr.	Glenn Wismer	Philip Maas	1:51.41
1991	Lite Light	Corey Nakatani	Jerry Hollendorfer	Oaktown Stable	1:48.8
1990	Seaside Attraction	Chris McCarron	D. Wayne Lukas	Overbrook Farm	1:52.8
1989	Open Mind	Angel Cordero Jr.	D. Wayne Lukas	Eugene V. Klein	1:50.6
1988	Goodbye Halo	Pat Day	Charlie Whittingham	Hancock III/A. Campbell Jr.	1:50.4
1987	Buryyourbelief	Jose A. Santos	Laz Barrera	D.S. Bray Jr.	1:50.4
1986	Tiffany Lass	Gary Stevens	Laz Barrera	Aaron U. Jones	1:50.6
1985	Fran's Valentine	Pat Valenzuela	Joseph Manzi	Earl Scheib	1:50.0
1984	Lucky Lucky Lucky	Angel Cordero Jr.	D. Wayne Lukas	Leslie Combs II/Equites St.	1:51.8
1983	Princess Rooney	Jacinto Vasquez	Frank Gomez	Paula J. Tucker	1:50.8
1982	Blush with Pride	Bill Shoemaker	D. Wayne Lukas	Stonereath Farms	1:50.2
1981	Heavenly Cause	Laffit Pincay Jr.	Woody Stephens	Ryehill Farm	1:43.8

Kentucky Oaks Winners

Year	Horse	Jockey	Trainer	Owner	Time
1980	Bold 'n Determined	Ed Delahoussaye	Neil Drysdale	Saron Stable	1:44.8
1979	Davona Dale	Jorge Velasquez	John M. Veitch	Calumet Farm	1:47.2
1978	White Star Line	Eddie Maple	Woody Stephens	Newstead Farm	1:45.2
1977	Sweet Alliance	Chris McCarron	Bud Delp	Windfields Farm	1:43.6
1976	Optimistic Gal	Braulio Baeza	LeRoy Jolley	Diana M. Firestone	1:44.6
1975	Sun and Snow	Garth Patterson	George T. Poole	C.V. Whitney Stables	1:44.6
1974	Quaze Quilt	William Gavidia	Thomas W. Kelley	Fred W. Hooper	1:46.6
1973	Bag of Tunes	D. Gargan	George T. Poole	C.V. Whitney Stables	1:44.2
1972	Susan's Girl	Victor Tejada	John W. Russell	Fred W. Hooper	1:44.2
1971	Silent Beauty	Kenny Knapp	R.I. Fischer	Leslie Combs II	1:44.2
1970	Lady Vi-E	David Whited	John Oxley	A.H. & A.M. Stall	1:44.8
1969	Hail to Patsy	David Kassen	Loyd Gentry Jr.	Walter Kitchen	1:44.4
1968	Dark Mirage	Manuel Ycaza	Everett W. King	Lloyd I. Miller	1:44.6
1967	Nancy Jr.	Johnny Sellers	Stanley M. Rieser	Hidden Valley Farm	1:44.0
1966	Native Street	Don Brumfield	Les Lear	Aisco Stable	1:44.8
1965	Amerivan	Ron Turcotte	Mary D. Keim	Mary D. Keim	1:44.4
1964	Blue Norther	Bill Shoemaker	Wally Dunn	Mrs. William R. Hawn	1:44.2
1963	Sally Ship	Manuel Ycaza	Woody Stephens	Cain Hoy Stable	1:44.8
1962	Cicada	Bill Shoemaker	Casey Hayes	Meadow Stable	1:44.6
1961	My Portrait	Braulio Baeza	Chuck R. Parke	Fred W. Hooper	1:47.0
1960	Make Sail	Manuel Ycaza	Woody Stephens	Cain Hoy Stable	1:44.2
1959	Wedlock	John L. Rotz	Paul Shawhan	Paul Shawhan	1:45.0

Year	Horse	Jockey	Trainer	Owner	Time
1959	Hidden Talent	Manuel Ycaza	Woody Stephens	Cain Hoy Stable	1:44.4
1958	Bug Brush	Eddie Arcaro	Sylvester Veitch	C.V. Whitney Stables	1:44.8
1957	Lori-El	Lois C. Cook	Mike R. Soto	Al Berke & M.R. Soto	1:44.8
1956	Princess Turia	Bill Hartack	Horace A. Jones	Calumet Farm	1:44.8
1955	Lalun	Henry Moreno	Loyd Gentry Jr.	Cain Hoy Stable	1:46.0
1954	Fascinator	Anthony DeSpirito	Edward A. Neloy	Maine Chance Farm	1:45.0
1953	Bubbley	Eddie Arcaro	Horace A. Jones	Calumet Farm	1:45.6
1952	Real Delight	Eddie Arcaro	Horace A. Jones	Calumet Farm	1:45.4
1951	How	Eddie Arcaro	Horatio Luro	H.B. Delman	1:45.6
1950	Ari's Mona	William Boland	J.C. Hauer	J.C. Hauer	1:43.6
1949	Wistful	Gordon Glisson	Ben A. Jones	Calumet Farm	1:47.4
1948	Challe Anne	Willie Garner	W.U. Ridenour	F.L. Flanders	1:48.6
1947	Blue Grass	Johnny Longden	Willie Crump	Arthur B. Hancock Jr.	1:51.6
1946	First Page	J.R. Layton	C.A. Bidencope	H.G. Jones	1:51.4
1945	Come and Go	C.L. Martin	J.P. Sallee	Thomas Piatt	1:49.8
1944	Canina	John H. Adams	Frank E. Childs	Abe Hirschberg	1:48.6
1943	Nellie L.	Wendell Eads	Ben A. Jones	Calumet Farm	1:48.6
1942	Miss Dogwood	John H. Adams	J.M. Goode	Brownell Combs	1:47.0
1941	Valdina Myth	George King	J.J. Flanigan	Valdina Farm	1:52.6
1940	Inscolassie	Bobby Vedder	R.O. Hugdon	Woolford Farm	1:54.4
1939	Flying Lill	Carroll Bierman	Clifford Porter	Mrs. C.H. Cleary	1:51.0
1938	Flying Lee	Leon Haas	Duval A. Headley	Hal Price Headley	1:52.8
1937	Mars Shield	Alfred Robertson	Robert McGarvey	Ethel Mars	1:53.4
1936	Two Bob	Raymond Workman	James W. Healy	C.V. Whitney Stables	1:52.6

Kentucky Oaks Winners

YEAR	HORSE	JOCKEY	TRAINER	OWNER	TIME
1935	Paradisical	Glenn Fowler	Al Miller	I.J. Collins	1:51.2
1934	Fiji	Gilbert Elston	T.B. Young	Young Bros.	1:51.6
1933	Barn Swallow	Don Meade	Herbert J. Thompson	Edward R. Bradley	1:51.2
1932	Suntica	Anthony Pascuma	Jack Whyte	Willis Sharpe Kilmer	1:52.2
1931	Cousin Jo	Eugene James	Wm. Reed	Charles Nuckols	1:53.0
1930	Alcibiades	Robert Finnerty	Walter W. Taylor	Hal Price Headley	1:52.6
1929	Rose of Sharon	Willie Crump	Dan E. Stewart	Johnson N. Camden Jr.	1:51.0
1928	Easter Stockings	Willie Crump	Kay Spence	Audley Farm Stable	1:51.6
1927	Mary Jane	Danny Connelly	S.S. Combs	Gallaher & Combs	1:53.4
1926	Black Maria	Arthur Mortensen	William H. Karrick	William R. Coe	1:55.4
1925	Deeming	James McCoy	C.B. Dailey	C.B. Dailey	1:54.0
1924	Princess Doreen	Harry Stutts	S. Miller Henderson	Audley Farm Stable	1:51.8
1923	Untidy	John Corcoran	Scott P. Harlan	Helen Hay Whitney	1:53.0
1922	Startle	Danny Connelly	J.I. Smith	H.H. Hewitt	1:52.6
1921	Nancy Lee	Linus McAtee	John H. McCormack	P.A. Clark	1:50.4
1920	Lorraine	Danny Connelly	J.C. Milam	J.N. Camden	1:58.4
1919	Lillian Shaw	T. Murray	John H. McCormack	J.R. Livingston	1:45.0
1918	Viva America	W. Warrington	W.N. Potts	C.T. Worthington	1:46.8
1917	Sunbonnet	Johnny Loftus	Walter B. Jennings	A. Kingsley Macomber	1:46.8
1916	Kathleen	Roscoe Goose	Pete Coyne	George J. Long	1:47.4

YEAR	HORSE	JOCKEY	TRAINER	OWNER	TIME
1915	Waterblossom	E. Martin	George Denny	Thomas McDowell	1:46.6
1914	Bronzewing	W. Obert	D. Lehan	A.P. Humphrey	1:45.6
1913	Cream	Carl Ganz	A. Baker	C.C. Van Meter	1:47.6
1912	Flamma	James Butwell	J. Duffy	E.F. Condran	1:51.2
1911	Bettie Sue	Ted Rice	D. Huestis	A. Brown	1:48.0
1910	Samaria	Richard Scoville	W. McDaniel	J.P. Ross & Co.	1:50.2
1909	Floreal	Heidel	W. H. Fizer	W.H. Fizer	1:49.2
1908	Ellen-a-Dale	Vincent Powers	George Denny	Thomas McDowell	1:46.6
1907	Wing Ting	J. Lee	J.S. Hawkins	J.S. Hawkins	1:50.2
1906	King's Daughter	E. Robinson	Thomas McDowell	Thomas McDowell	1:47.8
1905	Janeta	D. Austin	R.L. Rogers	Cassin & Rogers	1:49¾
1904	Audience	G. Helgeson	Sam S. Brown	H.C. Riddle	1:51
1903	Lemco	J. Reiff	F. Kelly	Edward Corrigan	1:49¾
1902	Wainamoinen	M. Coburn	H.J. Talbot	Talbot Bros.	1:51¼
1901	Lady Schorr	J. Woods	John F. Schorr	John W. Schorr	1:53
1900	Etta	Monk Overton	Edward D. Brown	Ed Brown & Co.	1:48
1899	Rush	J. Hill	Thomas McDowell	Thomas McDowell	1:52½
1898	Crocket	J. Hill	L. Cahn	J.C. Cahn	1:51½
1897	White Frost	Thomas H. Burns	L.C. Davis	E.S. Gardner & Son	1:49
1896	Soufflé	C. Thorpe	J. Healy	J.M. Murphy	1:54½
1895	Voladora	Alonzo Clayton	unknown	Pastime Stable	2:16¾
1894	Selika	Alonzo Clayton	John H. Morris	Bashford Manor Stable	2:15
1893	Monrovia	J. Reagan	Edward D. Brown	Edward D. Brown	2:16
1892	Miss Dixie	H. Ray	M. Danaher	Col. J.E. Pepper	2:14¼

Kentucky Oaks Winners

Year	Horse	Jockey	Trainer	Owner	Time
1891	Miss Hawkins	T. Britton	H.J. Talbot	Talbot Bros.	2:18¼
1890	English Lady	Hollis	unknown	Scoggan Bros.	2:42½
1889	Jewel Ban	John Stoval	W. Clay	John T. Clay	2:41
1888	Ten Penny	Andrew McCarthy Jr.	unknown	M. Welsh	2:42
1887	Florimore	Johnston	D.W. Kelly	T.H. Stevens	2:40¾
1886	Pure Rye	Edward Garrison	unknown	Melbourne Stable	2:41
1885	Lizzie Dwyer	Fuller	Edward Corrigan	Edward Corrigan	2:40¾
1884	Modesty	Isaac Murphy	Edward Corrigan	Edward Corrigan	2:48¼
1883	Vera	John Stoval	J. Pate	R.C. Pate	2:39¾
1882	Katie Creel	John Stoval	C.A. Johnson	Johnson & Co.	2:39
1881	Lucy May	Wolfe	unknown	R.F. Johnson	2:41
1880	Longitude	Jim McLaughlin	unknown	J.G. Malone	2.41¼
1879	Liahtunah	Hightower	unknown	J.A. Grinstead	2:40¼
1878	Belle of Nelson	Booth	unknown	Mattingly & Co.	2:39
1877	Felicia	W. James	unknown	J.W. Reynolds	2:39
1876	Necy Hale	W. James	unknown	F.B. Harper	2:42½
1875	Vinaigrette	J. Houston	unknown	A.B. Lewis & Co.	2:39¾

Appendix E

CLARK HANDICAP WINNERS

YEAR	HORSE	AGE	JOCKEY	TRAINER	OWNER	TIME
2009	Blame	3	Jamie Theriot	Albert Stall Jr.	Adele Dilschneider/ Claiborne Farm	1:49.39
2008	Einstein	6	Julien Leparoux	Helen Pitts-Blasi	M.L. Garretson, trustee	1:49.79
2007	A.P. Arrow	5	Ramon Dominguez	Todd Pletcher	Allen E. Paulson LT	1:48.66
2006	Premium Tap	4	Kent Desormeaux	John C. Kimmel	Kline/ Alevizos/ Whelihan	1:47.39
2005	Magna Graduate	3	John Velazquez	Todd Pletcher	Elisabeth Alexander	1:50.89
2004	Saint Liam	4	Edgar Prado	Rick Dutrow	M/M William K. Warren Jr.	1:50.81
2003	Quest	4	Javier Castellano	Nick Zito	A.B. Hancock III/G.F. Healy	1:52.42
2002	Lido Palace	5	Jorge F. Chavez	Robert J. Frankel	John & Jerry Amerman	1:49.13

Year	Horse	Age	Jockey	Trainer	Owner	Time
2001	Ubiquity	4	Craig Perret	William I. Mott	Gary & Mary West	1:48.26
2000	Surfside	3	Pat Day	D. Wayne Lukas	Overbrook Farm	1:48.75
1999	Littlebitlively	5	Calvin Borel	Bobby Barnett	John A. Franks	1:50.88
1998	Silver Charm	4	Gary Stevens	Bob Baffert	Bob & Beverly Lewis	1:49.00
1997	Concerto	3	Jerry Bailey	William I. Mott	Kinsman Stable	1:49.60
1996	Isitingood	5	David Flores	Bob Baffert	Mike Pegram & Terry Henn	1:48.80
1995	Judge TC	4	Joe Johnson	Gary G. Hartlage	Bea & Robert H. Roberts	1:49.80
1994	Sir Vixen	6	Dean Kutz	Mark Danner	Mark & Vickie Copass	1:51.20
1993	Mi Cielo	3	Mike E. Smith	Peter M. Vestal	Thomas M. Carey	1:51.40
1992	Zeeruler	4	Garrett Gomez	D.K. Von Hemel	John A. Franks	1:50.00
1991	Out of Place	4	Herb McCauley	C.R. McGaughey III	Cynthia Phipps	1:52.20
1990	Secret Hello	3	Pat Day	Frank L. Brothers	Lazy Lane Farm	1:50.60
1989	No Marker	5	Danny Cox	Patti Johnson	Billy Ray Gowdy	1:51.20
1988	Balthazar B.	5	Kent Desormeaux	Paul J. McGee	Paul J. McGee et al.	1:51.20
1987	Intrusion	5	Larry Melancon	Lee J. Rossi	Carl J. Maggio	1:51.40
1986	Come Summer	4	Patrick Johnson	George R. Arnold II	Surf & Turf Stable	1:49.80
1985	Hopeful Word	3	Pat Day	Carl Bowman	M. Clifton/R. Doll/B. Morris	1:51.00

Clark Handicap Winners

Year	Horse	Age	Jockey	Trainer	Owner	Time
1984	Eminency	6	Pat Day	C.R. McGaughey III	Happy Valley Farm	1:49.00
1983	Jack Slade	3	James McKnight	David Kassen	A. Adams	1:49.80
1982	Hechizado	6	Randy Romero	Ray Lawrence Jr.	Charles Schmidt Jr.	1:52.2
1981	Withholding	4	Larry Melancon	Ronnie Warren	M/M Russell Michael Jr.	1:52.00
1980	Sun Catcher	3	Don Brumfield	Dianne Carpenter	Sundance Stable/D. Nedeff	1:53.40
1979	Lot o' Gold	3	Julio Espinoza	Smiley Adams	Robert N. Lehmann	1:50.80
1978	Bob's Dusty	4	Richard dePass	Smiley Adams	Robert N. Lehmann	1:50.20
1977	Bob's Dusty	3	Richard dePass	Smiley Adams	Robert N. Lehmann	1:49.80
1976	Yamanin	4	Garth Patterson	George T. Poole	Hajima Doi	1:54.40
1975	Warbucks	5	Larry Melancon	Don Combs	E.E. Elzemeyer	1:54.40
1974	Mr. Door	3	William Gavidia	Thomas W. Kelley	unknown	1:52.20
1973	Golden Don	3	Mike Manganello	Oscar Dishman	Archie Donaldson	1:52.80
1972	Fairway Flyer	3	David Whited	John J. Greely III	William Floyd	1:53.80
1971	Sado	4	Don Brumfield	Harold Tinker	W. Cal Partee	1:53.60
1970	Watch Fob	5	Danny Gargan	George T. Poole	C.V. Whitney	1:51.20
1969	Bold Favorite	4	Doug Richard	Del W. Carroll	Michael G. Phipps	1:50.40
1968	Bold Favorite	3	Robert Nono	Del W. Carroll	Michael G. Phipps	1:49.20

Year	Horse	Age	Jockey	Trainer	Owner	Time
1967	Random Shot	4	Billy Phelps	James R. Cowden Jr.	James R. Cowden Sr.	1:50.80
1966	Flick II	4	Hector Pilar	Larry H. Thompson	unknown	1:49.60
1965	Big Brigade	4	Jimmy Nichols	E.S. Brumfield	M/M R.F. Roberts	1:50.80
1964	Lemon Twist	4	Billy Phelps	Pete Keiser	T.D. Buhl	1:50.60
1963	Copy Chief	3	Don Brumfield	S. Bryant Ott	Fourth Estate Stable	1:49.20
1962	Crimson Satan	3	Herb Hinojosa	Charley Kerr	Crimson King Farm	1:50.00
1961	Aeroflint	3	Eugene Curry	K.G. Hall	Mrs. Raymond Bauer	1:48.40
1960	Counterate	3	John L. Rotz	John J. Greely III	C.V. Whitney	1:49.00
1959	Las Olas	4	F.A. Smith III	C.E. Eads	Harry N. Eads	1:48.40
1958	My Night Out	5	E.J. Knapp	R. Grundy	Mr. Wells	1:50.00
1957	Ezgo	3	J. Delahoussaye	Larry H. Thompson	unknown	1:50.80
1956	Swoon's Son	3	David Erb	Lex Wilson	E. Gay Drake	1:50.60
1955	Happy Go Lucky	6	Lois C. Cook	Harold G. Bockman	Harold G. Bockman	1:51.60
1954	Bay Bloom	5	J. King	F.H. Pohl	F.H. Pohl	1:44.00
1953	Second Avenue	6	Carroll Bierman	Lex Wilson	unknown	1:45.60
1953	Chombro	6	Lois C. Cook	John Hanover	unknown	1:45.60
1952	Seaward	7	Kenneth Church	Harry Trotsek	Hasty House Farm	1:44.40
1951	Wistful	5	Douglas Dodson	Ben A. Jones	Calumet Farm	1:44.00
1950	Mount Marcy	5	Steve Brooks	Sylvester Veitch	C.V. Whitney	1:44.60

Clark Handicap Winners

Year	Horse	Age	Jockey	Trainer	Owner	Time
1949	Shy Guy	4	Conn McCreary	Jack C. Hodgins	Dixiana	1:45.20
1948	Star Reward	4	Steve Brooks	Jack C. Hodgins	Dixiana	1:46.60
1947	Jack S.L.	7	Steve Brooks	J.O. Ravannack	unknown	1:49.60
1946	Hail Victory	4	Douglas Dodson	Ben A. Jones	Calumet Farm	1:47.80
1945	Sentiment Sake	4	F. Wirth	Milton Rieser	unknown	1:47.20
1944	Alquest	4	Johnny Adams	Jack H. Skirvin	Ernst Farm	1:45.20
1943	Anticlimax	4	Carroll Bierman	K. Osborne	Hal Price Headley	1:46.00
1942	Whirlaway	4	Wendell Eads	Ben A. Jones	Calumet Farm	1:44.80
1941	Haltal	4	Conn McCreary	Steve Judge	unknown	1:44.80
1940	Up the Creek	4	G. Wallace	Roy Waldron	unknown	1:46.00
1939	Arabs Arrow	5	Carroll Bierman	Gilbert Hardy	Louise J. Hickman	1:45.80
1938	Main Man	4	W.F. Ward	Howard Hoffman	Jerome B. Respess	1:46.80
1937	Count Morse	4	Irving Anderson	Frank J. Kearns	Calumet Farm	1:45.20
1936	Corinto	4	Charley Kurtsinger	B.S. Mitchell	Mrs. Emil Denemark	1:44.80
1935	Beaver Dam	3	R. Montgomery	G. Gould	T.S. & J.S. Mulvihill	1:47.40
1934	Esseff	4	L. Humphries	Clyde Van Dusen	unknown	1:44.00
1933	Osculator	4	Silvio Coucci	Ben Creech	unknown	1:45.40
1932	Pittsburgher	4	Charles Corbett	J.H. Moody	Shady Brook Farm	1:50.20

Year	Horse	Age	Jockey	Trainer	Owner	Time
1931	Bargello	5	K. Russell	Mose Goldblatt	unknown	1:44.80
1930	Stars and Bars	4	L. Jones	Edward Haughton	Greentree Stable	1:47.40
1929	Martie Flynn	4	Carl Meyer	R. McGarvey	Syl Peabody	1:46.60
1928	Jock	4	Eddie Ambrose	John F. Schorr	John W. Schorr	1:45.00
1927	Helen's Babe	4	Walter Lilley	W.W. Taylor	unknown	1:46.00
1926	San-utar	5	Mack Garner	Pete Coyne	unknown	1:45.40
1925	Spic and Span	4	G. Fields	H. Unna	unknown	1:47.60
1924	Chilhowee	3	G. Harvey	John C. Gallaher	John & Allen Gallaher	1:54.40
1923	Audacious	7	B. Kennedy	A. Baker	Wilfrid Viau	1:54.60
1922	Exterminator	7	B. Kennedy	Henry McDaniel	Willis Sharpe Kilmer	1:50.00
1921	Ginger	5	T. Murray	K. Spence	H.H. Hewitt	1:45.00
1920	Boniface	5	Earl Sande	H. Guy Bedwell	J.K.L. Ross	1:45.80
1919	Midway	5	Harold Thurber	J.S. Ward	unknown	1:46.60
1918	Beaverkill	4	O. Willis	S.M. Henderson	Ogden Stable	1:48.20
1917	Old Rosebud	6	D. Connelly	Frank D. Weir	F.D. Weir & H.C. Applegate	1:45.20
1916	Hodge	5	C. Hunt	W.J. Weber	K. Spence	1:45.40
1915	Hodge	4	Charles Borel	W.J. Weber	K. Spence	1:44.60
1914	Belloc	3	A. Mott	E. Cunningham	unknown	1:45.00
1913	Buckhorn	4	Roscoe Goose	J.D. Adkins	R.J. MacKenzie	1:48.20
1912	Adams Express	4	Carroll H. Shilling	F.M. Taylor	unknown	1:45.20

Clark Handicap Winners

Year	Horse	Age	Jockey	Trainer	Owner	Time
1911	Star Charter	3	J. Wilson	G.M. Johnson	John W. Schorr	1:47.80
1910	King's Daughter	7	Ted Koerner	George Denny	Thomas C. McDowell	1:45.60
1909	Miami	3	Matt McGee	W.L. Lewis	Johnson N. Camden Jr.	1:45.20
1908	Polly Prim	5	Vincent Powers	Fred Luzader	J.R. Wainwright	1:58.80
1907	The Minks	4	David Nicol	W. Wells	unknown	1:50.80
1906	Hyperion II	3	W. McIntyre	J.S. Hawks	J.S. Hawks & Co.	1:49.00
1905	Batts	4	David Nicol	R.P. Brooks	unknown	1:53.75
1904	Colonial Girl	5	Lucien Lyne	C.E. Rowe	C.E. Rowe	1:48.75
1903	Love Labor	6	Scully	A. Hazlett	unknown	1:48.00
1902	Death	7	J. Slack	H. Robinson	unknown	1:47.00
1901	His Eminence	3	James Winkfield	Frank B. Van Meter	Frank B. Van Meter	1:55.00
1900	Lieut. Gibson	3	Jimmy Boland	Charles H. Hughes	Charles Smith	1:54.00
1899	Corsini	3	Nash Turner	Edward Corrigan	Edward Corrigan	2:01.60
1898	Plaudit	3	Robert Williams	John E. Madden	John E. Madden	1:56.50
1897	Ornament	3	Alonzo Clayton	C.T. Patterson	C.T. Patterson & Co.	1:55.00
1896	Ben Eder	3	Willie Simms	unknown	Hot Springs Stable	1:56.50
1895	Halma	3	Soup Perkins	Byron McClelland	Byron McClelland	2:15.50
1894	Chant	3	William Martin	H. Eugene Leigh	Leigh & Rose	2:19.50
1893	Boundless	3	Eddie Kunze	W. McDaniel	Cushing & Orth	2:12.00

Year	Horse	Age	Jockey	Trainer	Owner	Time
1892	Azra	3	Alonzo Clayton	John H. Morris	Bashford Manor Stable	2:20.00
1891	High Tariff	3	Monk Overton	unknown	Eastin & Larabie	2:12.00
1890	Riley	3	Isaac Burns Murphy	Edward Corrigan	Edward Corrigan	2:16.25
1889	Spokane	3	Thomas Kiley	John Rodegap	Noah Armstrong	2:12.50
1888	Gallifet	3	Andrew McCarthy Jr.	unknown	Melbourne Stable	2:15.25
1887	Jim Gore	3	L. Jones	unknown	A.G. McCampbell	2:11.25
1886	Blue Wing	3	Edward Garrison	unknown	Melbourne Stable	2:10.00
1885	Bersan	3	Isaac Burns Murphy	Green B. Morris	Morris & Patton	2:09.25
1884	Buchanan	3	Isaac Burns Murphy	William Bird	William Cottrill	2:12.00
1883	Ascender	3	John Stoval	J. Pate	R.C. Pate	2:18.00
1882	Runnymede	3	Jim McLaughlin	James G. Rowe Sr.	Dwyer Bros. Stable	2:15.50
1881	Hindoo	3	Jim McLaughlin	James G. Rowe Sr.	Dwyer Bros. Stable	2:10.25
1880	Kinkead	3	Jim McLaughlin	unknown	unknown	3:37.75
1879	Falsetto	3	Isaac Burns Murphy	Eli Jordan	J.W. Hunt Reynolds	3:40.50
1878	Leveller	3	Robert Swim	unknown	R.H. Owens	3:37.00
1877	McWhirter	3	C. Miller	unknown	Abraham Buford II	3:30.50
1876	Creedmore	3	Howard D. Williams	unknown	Williams & Owings	3:34.75
1875	Voltigeur	3	McGrath	B. Green	W.G. Harding	3:30.75

BREEDERS' CUP WINNERS

1988

RACE	WINNER	JOCKEY	TRAINER
Juvenile Fillies	Open Mind	A. Cordero Jr.	D. Wayne Lukas
Juvenile	Is It True	L. Pincay Jr.	D. Wayne Lukas
Sprint	Gulch	A. Cordero Jr.	D. Wayne Lukas
Mile	Miesque	F. Head	F. Boutin
Turf	Great Communicator	R. Sibile	T. Ackel
Distaff	Personal Ensign	R. Romero	C.R. McGaughey III
Classic	Alysheba	C. McCarron	J. Van Berg

1991

RACE	WINNER	JOCKEY	TRAINER
Juvenile Fillies	Pleasant Stage	E. Delahoussaye	C. Speckert

RACE	WINNER	JOCKEY	TRAINER
Juvenile	Arazi	P. Valenzuela	F. Boutin
Sprint	Sheikh Albadou	P. Eddery	A. Scott
Mile	Opening Verse	P. Valenzuela	R. Lundy
Turf	Miss Alleged	E. Legrix	P. Bary
Distaff	Dance Smartly	P. Day	J. Day
Classic	Black Tie Affair	J. Bailey	E. Poulos

1994

RACE	WINNER	JOCKEY	TRAINER
Juvenile Fillies	Flanders	P. Day	D. Wayne Lukas
Juvenile	Timber Country	P. Day	D. Wayne Lukas
Sprint	Cherokee Run	M. Smith	F. Alexander
Mile	Barathea	L. Dettori	L. Cumani
Turf	Tikkanen	M. Smith	J. Pease
Distaff	One Dreamer	G. Stevens	T. Proctor
Classic	Concern	J. Bailey	R. Small

1998

RACE	WINNER	JOCKEY	TRAINER
Juvenile Fillies	Silverbulletday	G. Stevens	B. Baffert
Juvenile	Answer Lively	J. Bailey	B. Barnett
Sprint	Reraise	C. Nakatani	C. Dollase
Mile	Da Hoss	J. Velasquez	M. Dickinson
Turf	Buck's Boy	S. Sellers	P. Noel Hickey
Distaff	Escena	G. Stevens	W. Mott
Classic	Awesome Again	P. Day	P. Byrne

2000

RACE	WINNER	JOCKEY	TRAINER
Juvenile Fillies	Caressing	J. Velasquez	D. Vance
Juvenile	Macho Uno	J. Bailey	J. Orseno
Sprint	Kona Gold	A. Solis	B. Headley
Mile	War Chant	G. Stevens	N. Drysdale
Turf	Kalanisi	J. Murtagh	Sir M. Stoute
Filly & Mare Turf	Perfect Sting	J. Bailey	J. Orseno
Distaff	Spain	V. Espinoza	D. Wayne Lukas
Classic	Tiznow	C. McCarron	J. Robbins

2006

RACE	WINNER	JOCKEY	TRAINER
Juvenile Fillies	Dreaming of Anna	R. Douglas	W. Catalano
Juvenile	Street Sense	C. Borel	C. Nafzger
Sprint	Thor's Echo	C. Nakatani	D. O'Neill
Mile	Miesque's Approval	E. Castro	M. Wolfson
Turf	Red Rocks	F. Dettori	B. Meehan
Filly & Mare Turf	Ouija Board	F. Dettori	E. Dunlop
Distaff	Round Pond	E. Prado	M Matz
Classic	Invasor	F. Jara	K. McLaughlin

NOTES

PROLOGUE

1. Tom Stephens, "A Match for the Ages," *Louisville Journal*, April 1, 2008.
2. Ibid.
3. John Kleber, *The Encyclopedia of Louisville* (Louisville: University Press of Kentucky, December 4, 2000).
4. Ibid.
5. Samuel Thomas, *Churchill Downs: A Documentary History of America's Most Legendary Race Track* (Louisville: Kentucky Derby Museum, January 1, 1995).

CHAPTER 1

6. *The Turf, Field and Farm*, "The Louisville Jockey Club," July 10, 1874.
7. *Courier-Journal*, "Our Derby Day," May 16, 1875.
8. *Daily Louisville Commercial*, "Paris Mutuals," May 1, 1875.
9. *Louisville Herald Post*, "Champion Derby Fans to See Big Event 54th Time," May 13, 1929. Cited in Thomas, *Churchill Downs*.
10. *Daily Louisville Commercial*, "Derby Day," April 25, 1875.
11. Susan Dor, "Derby Day Traditions," Emerils.com, May 4, 2000.
12. *New York Times*, April 3, 1878.
13. Kleber, *Encyclopedia of Louisville*.
14. *Courier-Journal*, "At the Track," May 15, 1883.

15. *Louisville Commercial*, "Lively at the Downs," February 17, 1890.

16. Ibid., May 16, 1894.

17. "The Twin Spires," www.kentuckyderby.com.

18. *Courier-Journal*, "A Splendid Structure," February 4, 1895.

19. *Louisville Commercial*, "The Grand Stand," May 6, 1985.

20. *New York Times*, April 23, 1899.

CHAPTER 2

21. *Courier-Journal*, "First Concert at Jockey Club Park," June 1, 1903.

22. *New York Times*, May 18, 1909.

23. Kleber, *Encyclopedia of Louisville*.

24. *New York Times*, June 18, 1910.

25. Matt Winn with Frank G. Menke, *Down the Stretch: The Story of Colonel Matt J. Winn* (New York: Smith & Durrell, 1944).

26. *Louisville Herald*, May 8, 1920. Cited in Thomas, *Churchill Downs*.

27. *Courier-Journal*, April 6, 1920. Cited in Thomas, *Churchill Downs*.

CHAPTER 3

28. Thomas, *Churchill Downs*.

CHAPTER 4

29. Greg Kocher, "The Great Depression Saw Great Racing, Less Wagering," *Lexington Herald Leader*, April 27, 2009.

30. Bennett Liebman, "Origins of the Triple Crown," *New York Times*, April 24, 2008.

31. William F. Reed, "Duking It Out in the Derby," *Sports Illustrated*, April 5, 1993.

32. Kocher, "Great Depression."

33. Thomas, *Churchill Downs*.

34. *Time*, "Sport: 63rd Derby," May 10, 1937.

35. Winn with Menke, *Down the Stretch*.

36. Kocher, "Great Depression."

Chapter 5

37. Kleber, *Encyclopedia of Louisville*.

Chapter 6

38. Barry Irwin, "Swaps: Invader from the West," *Blood-Horse*, August 31, 2005.
39. Maurice Shevlin, "13 to Start in $25,000 Beverly Today," *Chicago Daily Tribune*, June 3, 1961.

Chapter 7

40. Thomas, *Churchill Downs*.

Chapter 10

41. NTRA, *Spiraling to the Breeders' Cup*, part 2.
42. Adam Z. Saint Cloud, "Cadillac Colt: The Favorite to Win the Kentucky Derby, Arazi Races Like the Second Coming of Secretariat," *Time*, May 4, 1992.

Chapter 11

43. Evan Hammonds, "Churchill Unveils Statue of Pat Day," *Blood-Horse*, October 29, 2006.
44. Sally Jenkins, "Is Horse Racing Breeding Itself to Death?" *Washington Post*, May 4, 2008.
45. Thomas, *Churchill Downs*.

ABOUT THE AUTHOR

Kimberly Gatto is a professional writer specializing in equestrian and sports books. Her published works to date include two horse-related titles and several athlete biographies. Her work has been included in various publications, including the *Blood Horse*, the *Chronicle of the Horse*, the *Equine Journal* and *Chicken Soup for the Horse Lover's Soul*. Gatto is an honors graduate of Boston Latin School and Wheaton College. A lifelong rider and horsewoman, she is the proud owner of Grace, a lovely off-the-track thoroughbred.

Visit us at
www.historypress.net